# RANDOM ACTS OF ART

*Maia Newley*

# RANDOM ACTS OF ART

© MAIA NEWLEY ART 2013

# INDEX

Acknowledgements ………………………… 4

Foreword ………………………………… 5

Preface …………………………………… 8

Artworks ………………………………… 12

# ACKNOWLEDGEMENTS

This book is a compilation of years of paintings and artworks, including various different series and a variety of different media.  I would be extremely remiss if I attempted to name all those people who have supported me, helped me and continued to love me throughout the making of ALL of these works and I would also probably bore the reader rigid!  Therefore I will limit myself to saying that I thank each and every person who has helped me along the way; whether tangentially or centrally but, in particular, I want to give a small number of specific mentions in order to thank those people without whom my life and art would not have been possible at all.

Firstly, to John, for loving me way beyond any sense of rationality or resason, to John Markton and Amanda Perstatten for their unswerving support in the face of adversity and for their excellent proofing skills, to Lisa Minarovich for just being the best friend I could ever wish for, to Charlie for just being you, to Rich for being central to my life in oh so many ways and to Jack for continuing to pull the rabbit out of the hat despite no one having any idea how he does it!

Thanks to all...

                                                                                                                                MN

*"In the depth of winter I finally learned that there was in me an invincible summer."*
*Albert Camus*

# FOREWORD

## About Maia Newley

Maia Newley is an abstract expressionist artist who lives between the USA and the UK. Her work focusses predominantly on colors, textures and emotions and the interplay between all three. Her previous series have included "Dante – Inferno – Hell" and "Faustus – Denouement – The Conclusion" which both explore the relationship between mankind, evil, eternality and man's belief in the supernatural.

She has exhibited in the USA, UK and Europe and is committed to producing 'accessible art' which is shown in appropriately accessible environments. She has regularly shunned opportunities of exhibiting in conventional galleries in favor of open-air, freely-accessible exhibitions and open-space galleries which offer full access to visitors with no entrance fee. She strongly believes that art belongs to everyone and should not be viewed any differently to music (which she also composes) – everyone should have free access to art if they wish to view it. She views her work as coming from an anarchistic start point and, for this reason, she endeavors to ensure her work is available and viewable to anyone who wishes to see it, regardless of income, status or education. As Maia herself says :

*"... There are some galleries I have exhibited in in the past, where even I, as the artist, feel uncomfortable going in the door – as though I am entering some hallowed hall where I can only walk in if I am wearing the right outfit and only speak in whispers using words of more than three syllables. Goodness alone knows how the casual passer-by might feel on seeing the work through the window and wishing to pop in to view it in more detail. I do not want my art work displayed in such a place. Life is art and art is life, and therefore is it imperative that we do not separate the two or put one on a pedestal above the other."*

Although Maia works predominantly as an expressionist, she also has occasional forays into the areas of symbolism and fauvism. Over the years she has worked with a plethora of different media including sculpture, stone casting, metalwork, pyrography, stained glass window design and more conventional painting. She is also a photographer.

When asked about her work, Maia says :

*"I don't have a whole lot to say really as I prefer the art to speak for itself. In my opinion art needs to be accessible to all those who wish to see it. What any given piece means to me is mostly irrelevant as the viewer should decide what it means to THEM. In this way, I hope that each piece can develop its own meaning for each person who views it.*

*I prefer not to give long explanations with the artwork as, for me, art is about feeling and emotion and not about words.*

*My main interest is in producing pieces which focus on areas of the world about us which we mostly don't bother to look at! Individual rain drops, small parts of brickwork, clumps of earth - in other words, I focus on the minute details which do not generally draw our attention when we look at the overall subject matter.*

*My work is mostly abstract expressionist in nature, but I seem to have a natural affinity with symbolism which is hard to shake-off and so much of my work is underpinned with a symbolistic conception which then mutates and grows into its expressionistic form. I find the fusion of the two styles is probably the best way of understanding who I am as a person - that paradox, between the more stylized and regulated symbolism and the randomness of the expressionistic conclusion accurately reflects the seemingly interminable conflict which exists within my mind between order and chaos. After years of trying to resolve the conflict, I have now finally concluded that I am who I am BECAUSE of that conflict and not in spite of it!*

*If you're looking for representational art, you won't find it here! For me, if you want to look at fine art paintings of landscapes, buy a camera and take photos! If you want to look at how a landscape makes someone FEEL, look at art".*

MN

# PREFACE

## About Random Acts of Art

Random Acts of Art came about as a seed of an idea in my mind several years ago. I have often felt compromised when showing my artwork at exhibitions as they cost a fortune to put on and, in my opinion, the average artist would really have great difficult finding the money necessary to exhibit at any decent exhibition space.

When I first started out as an artist, I was naive enough to believe that if one was talented enough, one would be able to gain the interest of galleries and hopefully then go on to exhibit their work. How wrong I was! It seems to me that the whole 'business' of art has become shallow, introspective, and very self-congratulatory in recent years. If you have the money, you will find galleries queuing up to exhibit your work; if you don't, you won't.

A case in point is a very well-known and well-respected London Gallery who shall remain nameless as I have some sympathy with their position, offered me the opportunity to take part in a running exhibition they have. It really was a marvellous opportunity for me, the gallery was well-considered by those 'in the know' in the art world, was eagerly reviewed by the art critics and their exhibition space was well-appointed both geographically and artistically. In all, I loved the space. However, when it came down to the nitty-gritty, I realised that it would cost me around £2000 to exhibit my paintings there for around ten days or two weeks. The gallery themselves would charge me around £600 (including VAT), then I would have to frame my paintings and artworks and get them gallery-ready (some would need adhering to board, others would need actual framing), then I would have to find an art transport company to actually GET them to the gallery in question from which I lived a couple of hundred miles. To be fair to this particular gallery, their charges for exhibiting are fairly low when compared with other London art spaces and they do offer quite a good package; they will hang your work for you, invite press and others to a launch night, provide drinks and nibbles and so on and do a whole host of publicity-related things to promote the exhibition and this is why I said earlier that, with this particular gallery, I DO have some sympathy, they are providing an excellent service in many ways – the fact that the overall costs are probably beyond the average as-yet-unknown artist is apparently beside the point.

Other exhibition spaces which call themselves 'galleries' are, in reality, art shops which offer to display your work for a percentage of the final sale amount. That's fine and dandy and, in actual fact, seems a much fairer way of doing things – until you realise that some of these city-based galleries charge 95% commission! This means that, in order to make any money at all on your work if sold, or at least in order not to lose any money, you have to price your work far higher than you would otherwise making it out of reach of the pocket of the average passer-by!

So, in all, it's a conundrum...

Having said all of this, do not think that I am against galleries, I'm not. Galleries can offer wonderful exposure to artists and are often very enthusiastic and very discerning as to the artwork they choose to show. However, at the bottom of it all, is money. Either you have it or you don't.

Art should not be about money. I know, I know, this is naïve of me but, truth be told, somewhere in the mix of this whole quagmire, there MUST be something about talent. Surely?

A gallery who had waxed lyrical about how marvellous a particular series of artworks of mine were and offered me, repeatedly, exhibition space suddenly lost all interest when I tried to negotiate with them on fees. They offered no defence or justification for their (in this case outrageous) fees, simply said if I couldn't pay, they were no longer interested. And this, my friends, sums up the art world in these days of greed and gluttony.

When people sometimes ask "how on EARTH is that particular artist famous and successful?" it sometimes reflects merely the subjective nature of art but, at other times, this reflects very accurately in my opinion, the cess pit of greed that is rapidly becoming the entire art world. The haves and the have nots – an old phrase and not one I would have previously associated with art and artists, but I do now.

As an anarchist artist I therefore find myself in a very tricky situation – my own financial position aside, I cannot in all conscience, create art which focusses on anarchy, liberalism, equality and 'fairness' if I then pay out thousands of pounds, dollars or cents every time I wish to show my work. Quite apart from that being utterly hypocritical, it also doesn't make me feel very good about my work. How am I meant to know if it's any good or not if the assessment is based purely on my bank balance and not on the works themselves. I've had even had galleries offer me gallery space without even taking a LOOK at my work! This is what we have come to. And it needs to stop.

I agree that galleries have overheads and that galleries in the larger towns and cities often have larger overheads than the suburban galleries but there really does need to be a way of making this work differently. The commission model is one I favour most as it allows the artist to exhibit regardless of their personal wealth but, on the other hand, if the artist doesn't sell, then the gallery would lose out financially and that's not acceptable either. I suppose I would favour more realistic fees, maximum of £30 or £35 per artwork, or even perhaps to charge by the size of the work (since we are really talking about gallery 'space' here) and then, of course, commission on top of that. If the artist doesn't sell, then don't show them again – seems quite simple to me!

I'd love to know if anyone else has potential solutions to this seemingly eternal conundrum and, if you do, please let me know!

And so, to return to the subject of Random Acts of Art; it had been my intention for quite a few years, to produce a compilation of my artwork including some very early pieces that I rarely show these days, and moving forward to the most recent series of artworks that I have created – a little bit of everything to allow new readers to get an idea of what I'm all about, and for those who have followed my career for a while, a book which would encompass everything in one go without rendering the previous books, made up of individual exhibitions and series, useless.

Therefore, Random Acts of Art includes a little bit of everything.

As I always say to potential viewers of my work : what any of it means to me is largely irrelevant, it's all about what it means to YOU.  How does it make you feel?  What does it make you think of?  I've always wished there was a more interactive way of ascertaining these things and I would urge any of you who feel so moved, email me and let me know what you feel when viewing it, let me know what you see in my paintings, tell me which colours appeal to you and why.

Go on, you know you want to!

Other than that, it only remains for me to say, art is all about pleasure; and remember, life is art and art is life...

ENJOY...

# RANDOM ACTS OF ART

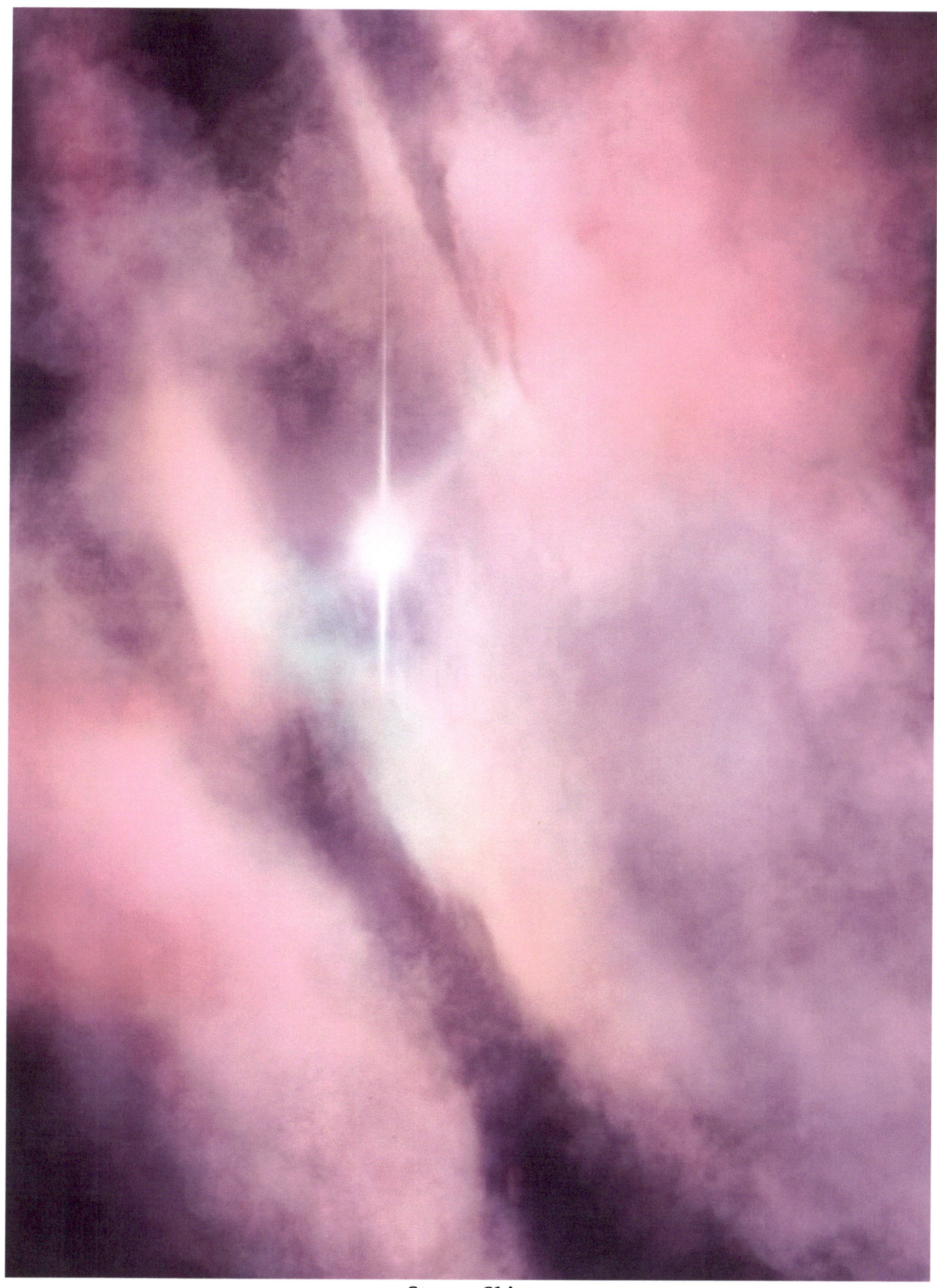

**Stormy Skies**

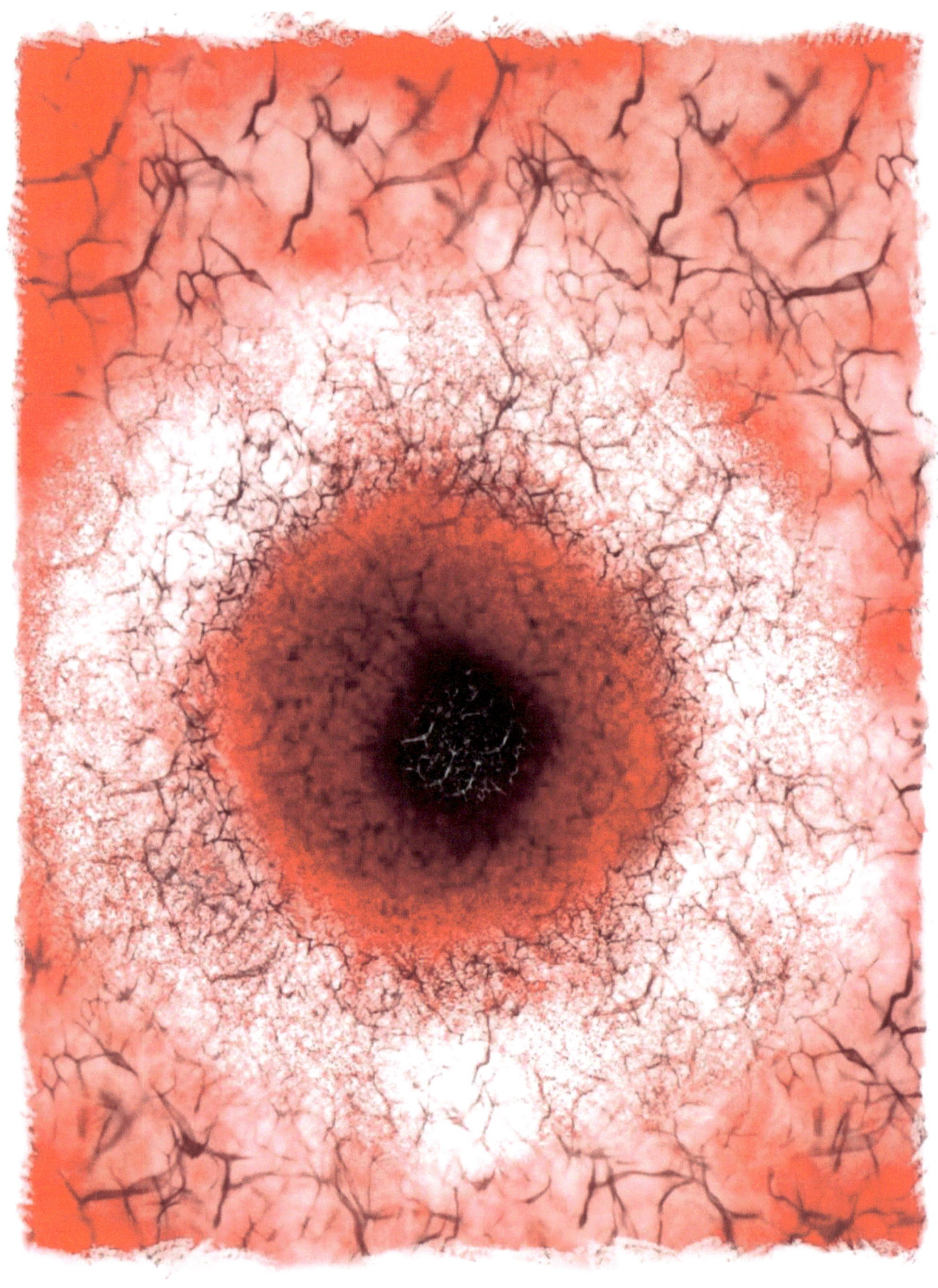

**Tired Poppy**

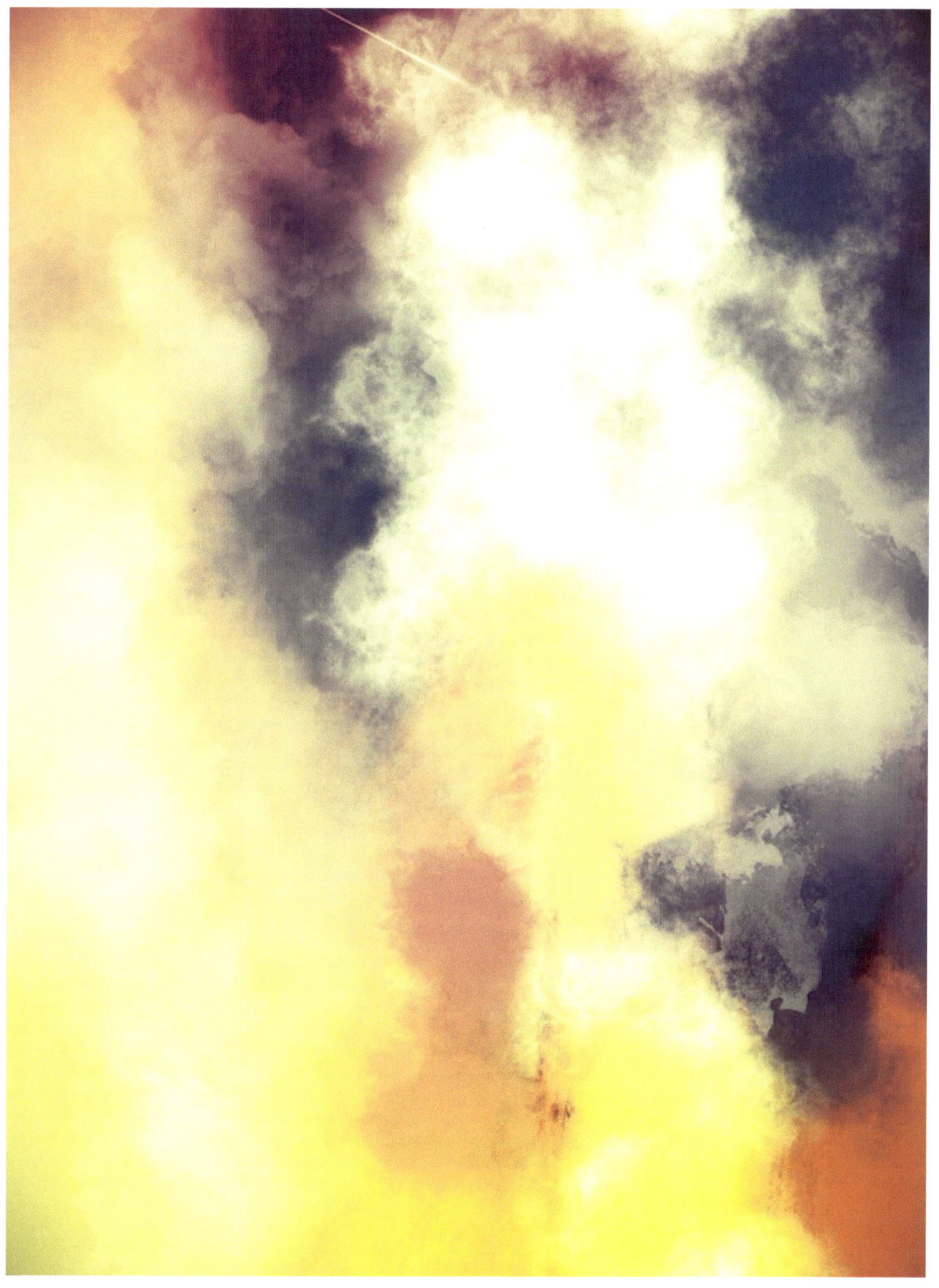

**Sea Storm**

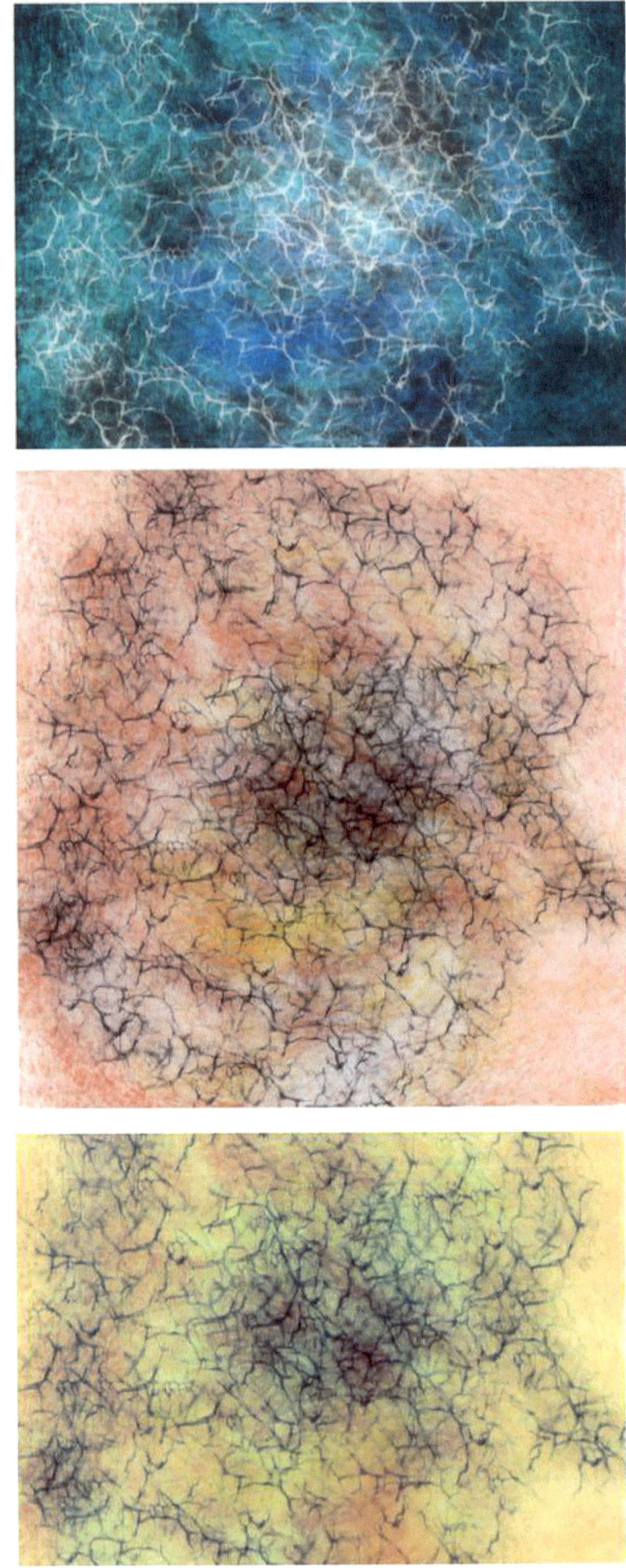

**The Three Faces of Id (Triptych)**

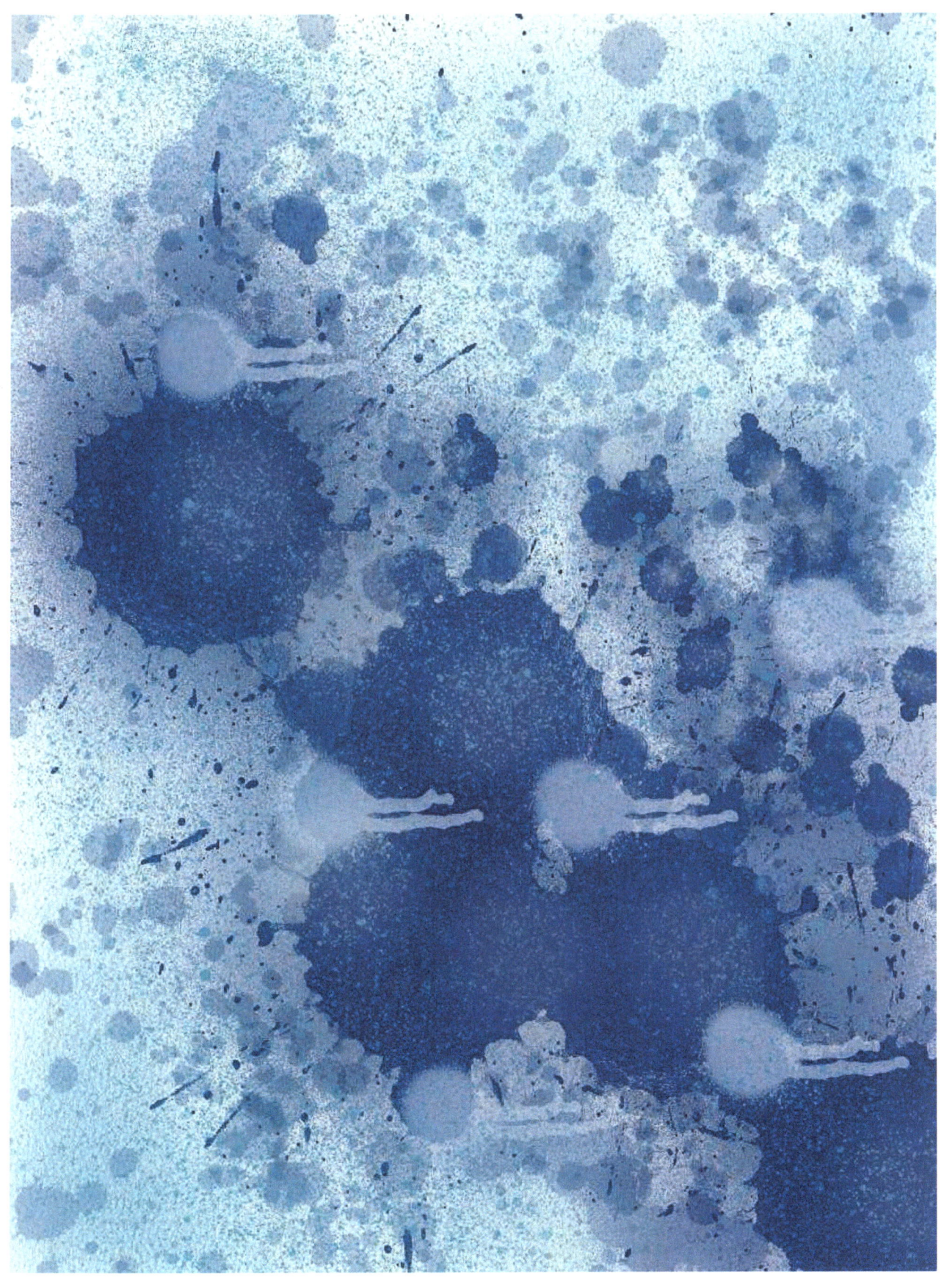

**Winter Fireworks**

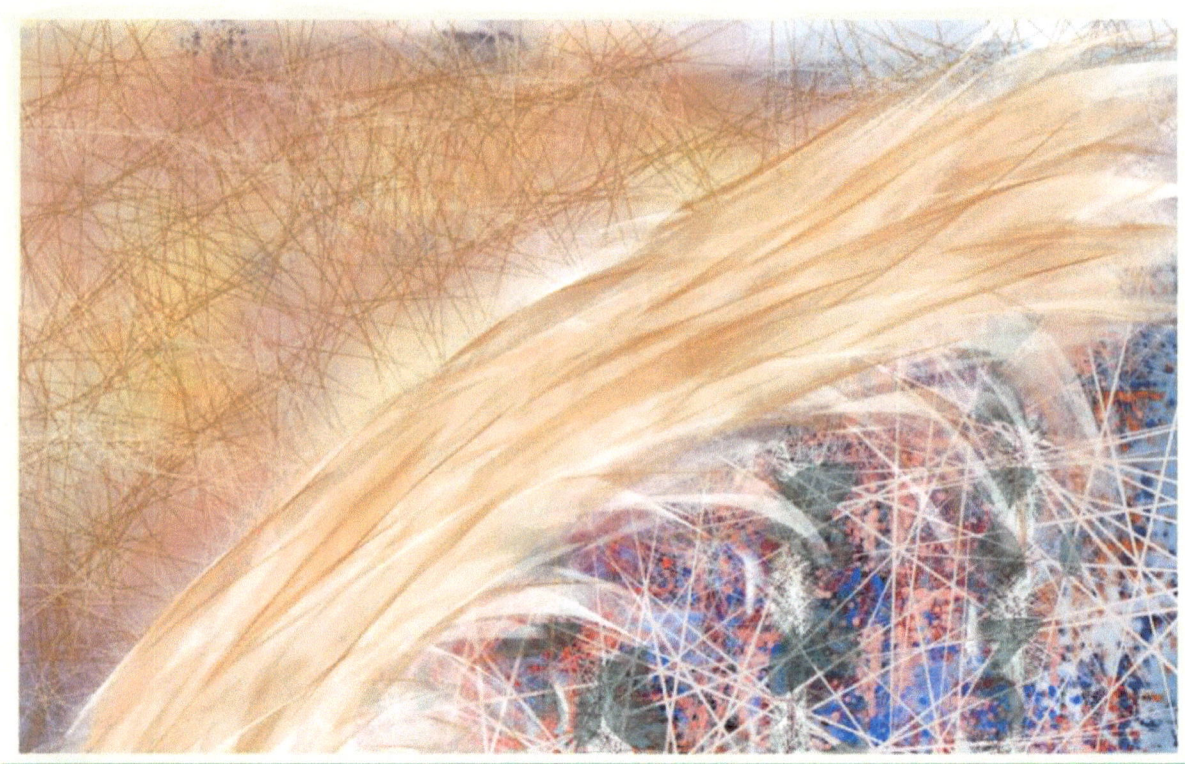

Life...

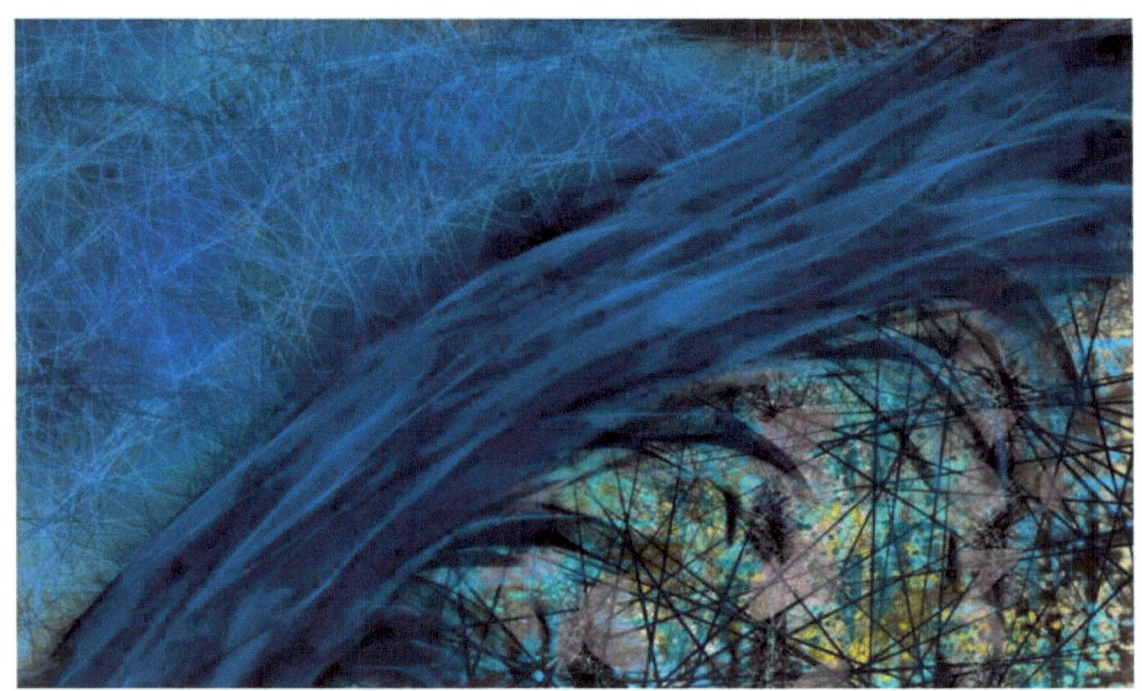

Life...

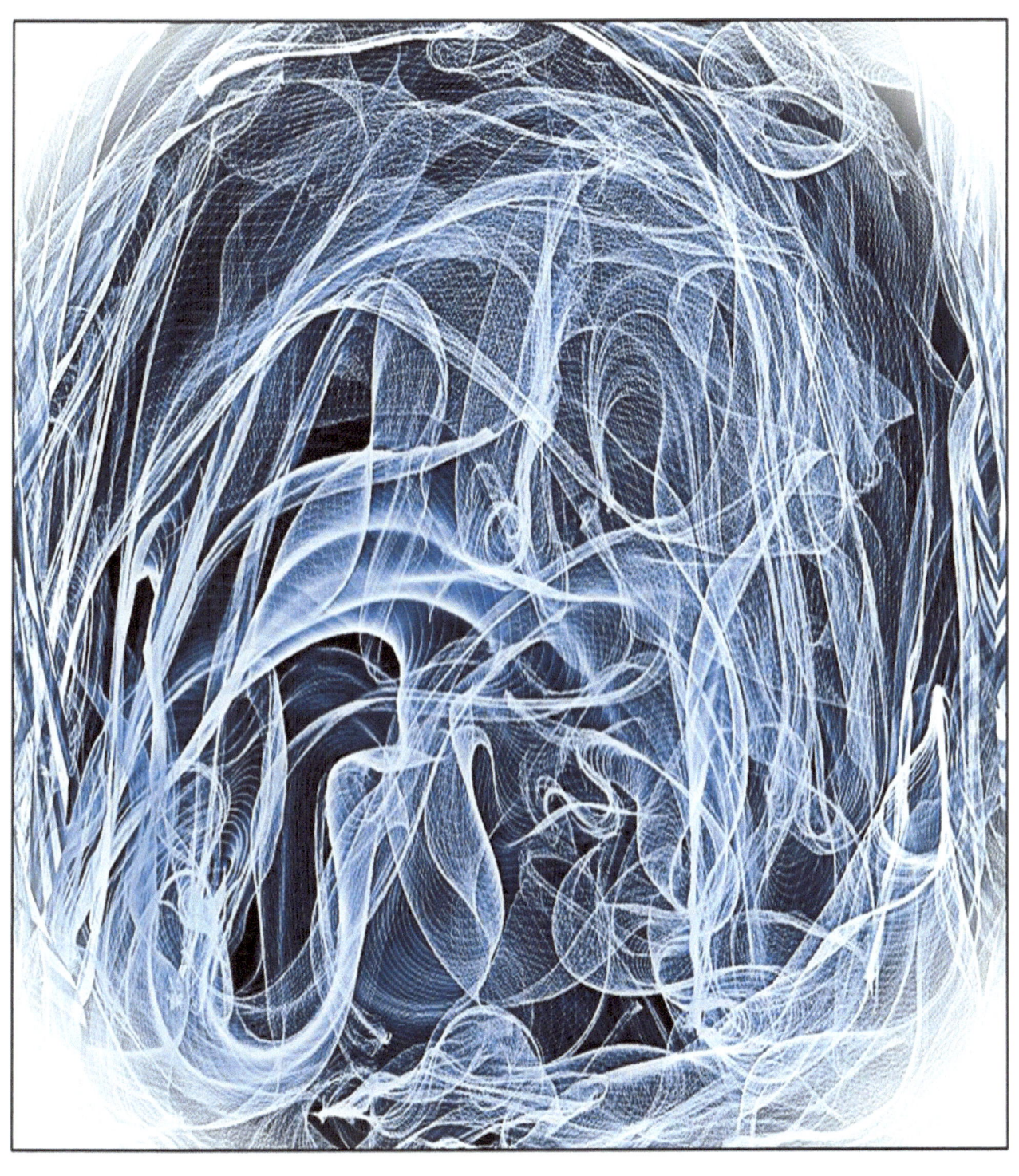

Complex Relationship

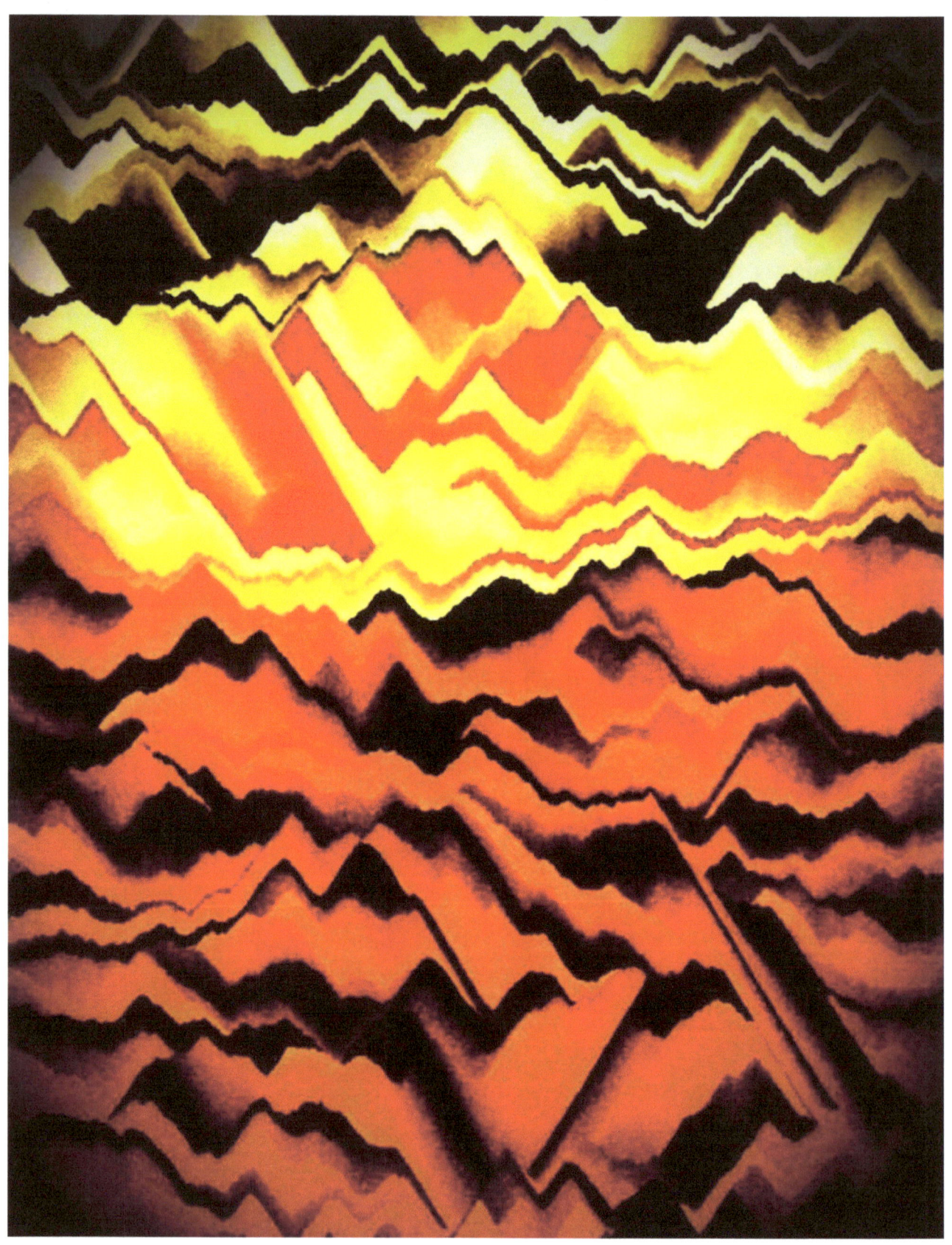

**Hell - Inferno**

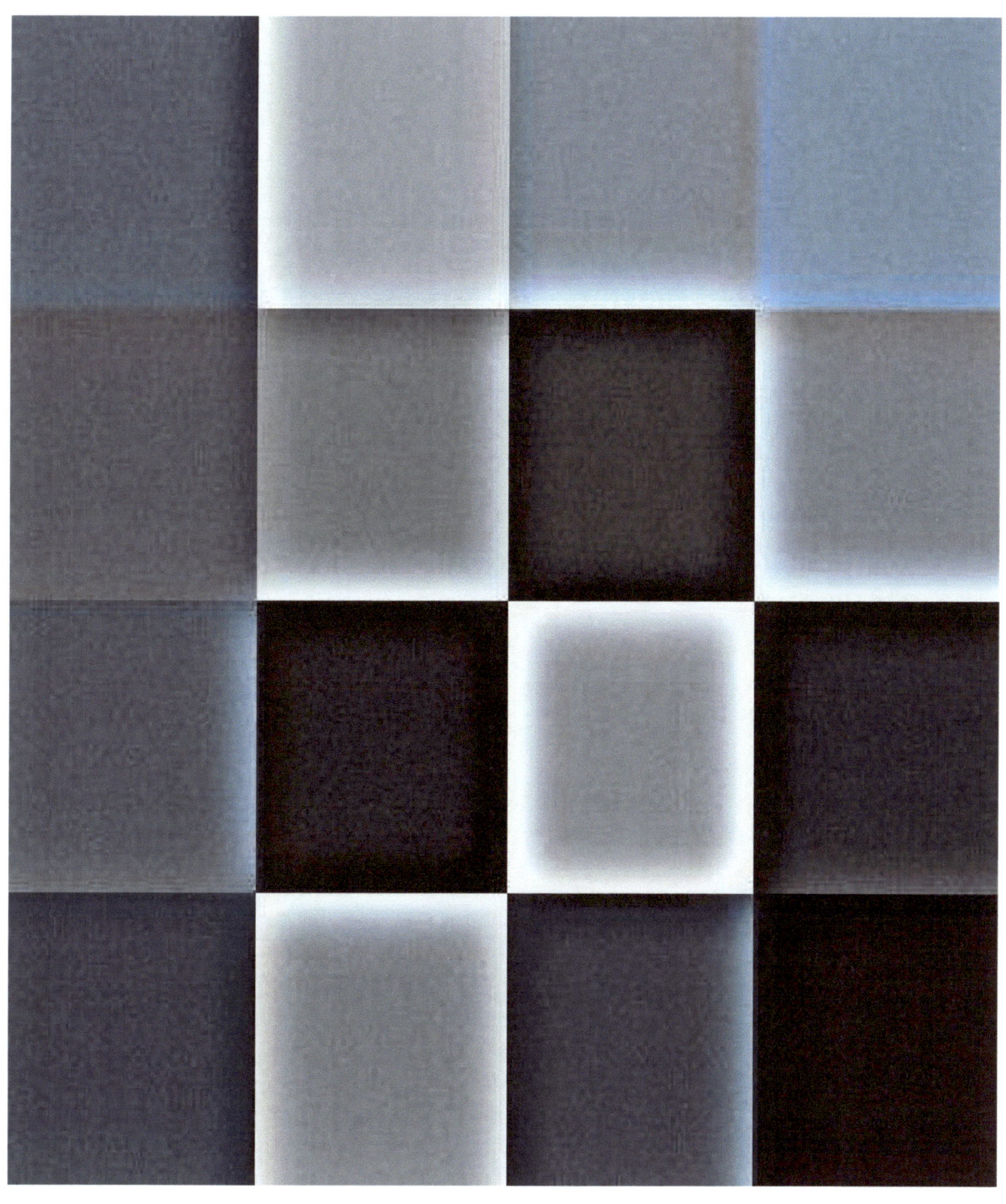

**From the "Call Me Ishmael" series of paintings**
**Screenprint**

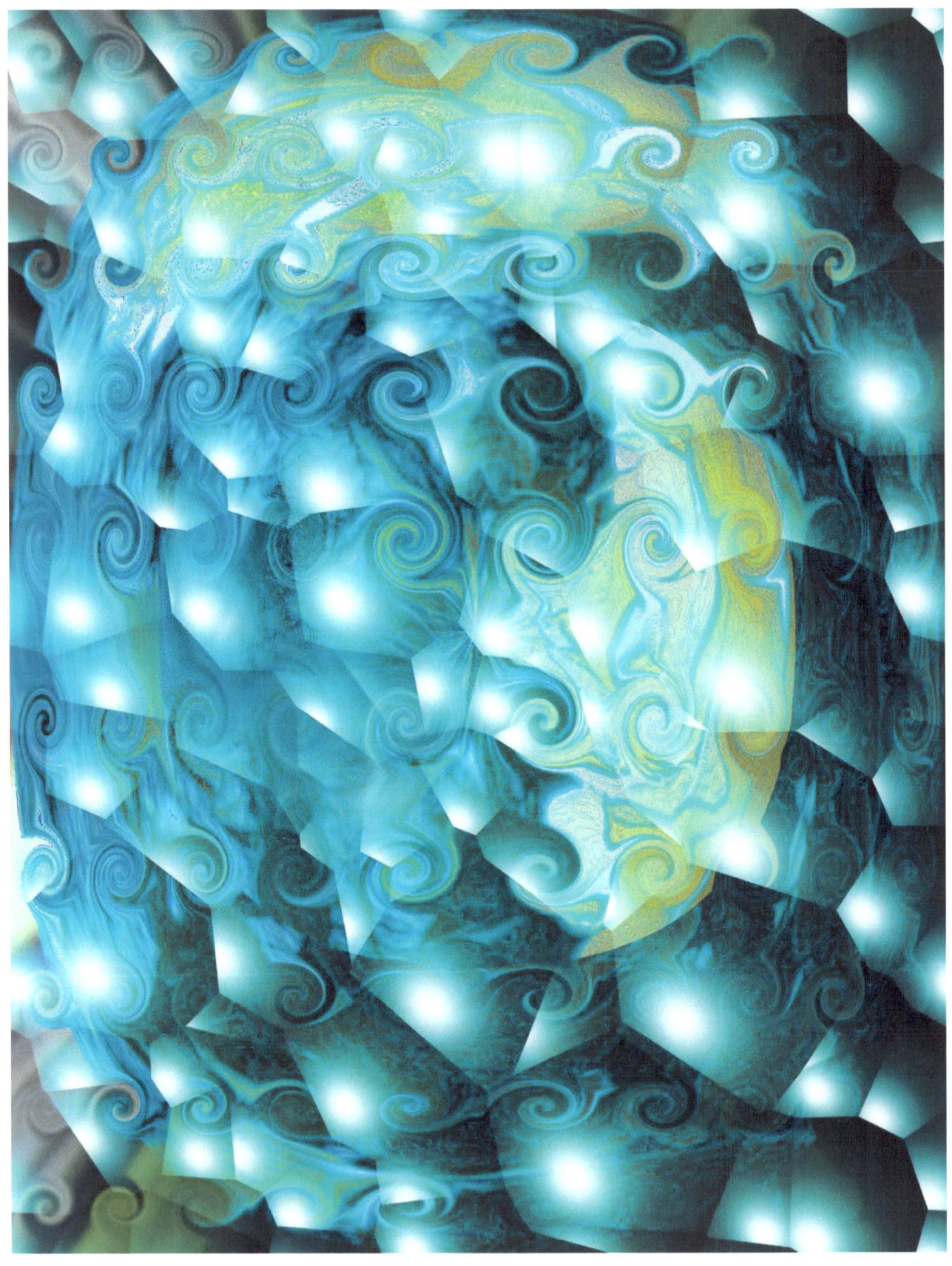

**Chaos #9**
Screenprint

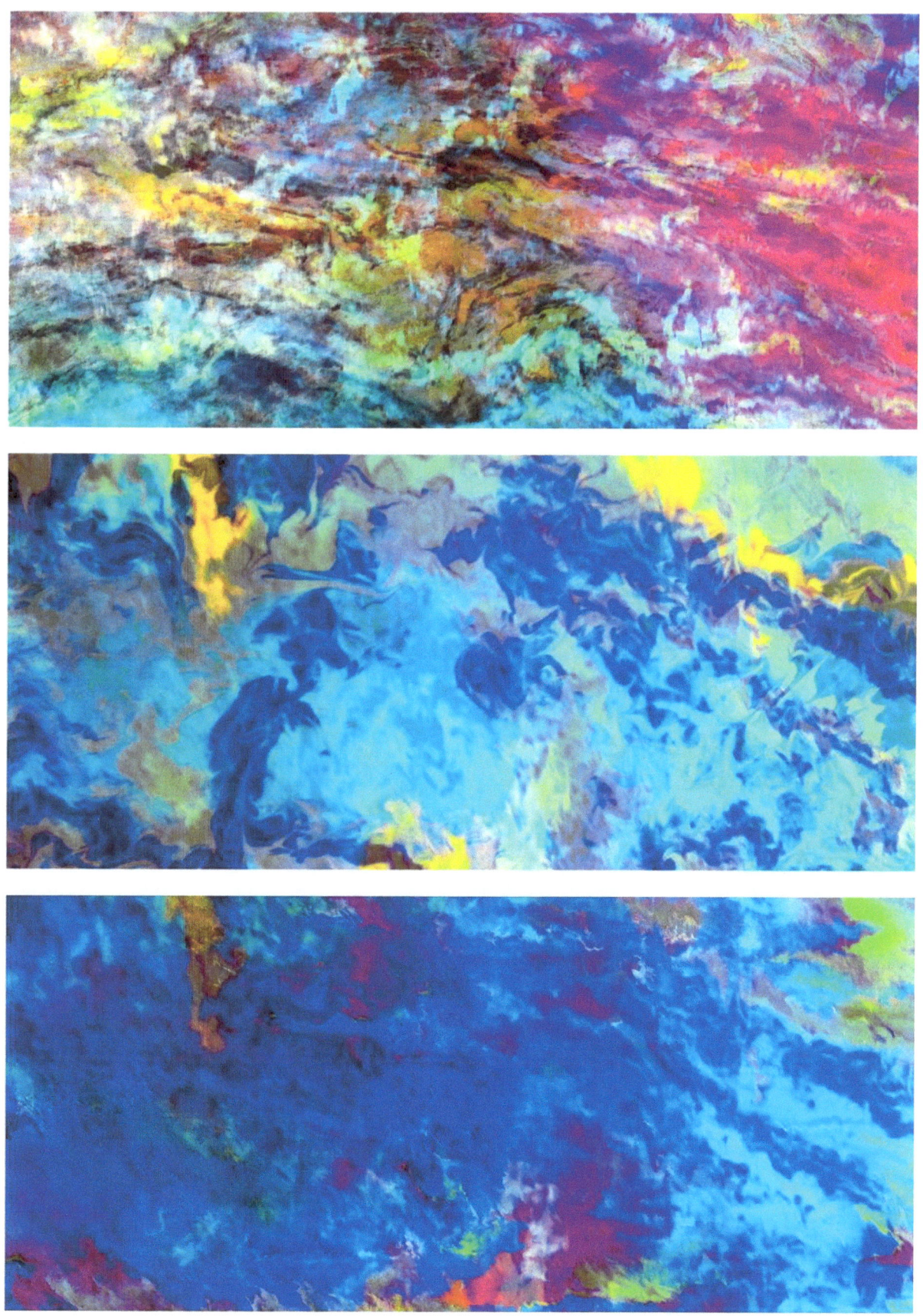

**From the Dante – Inferno – Hell series of paintings**

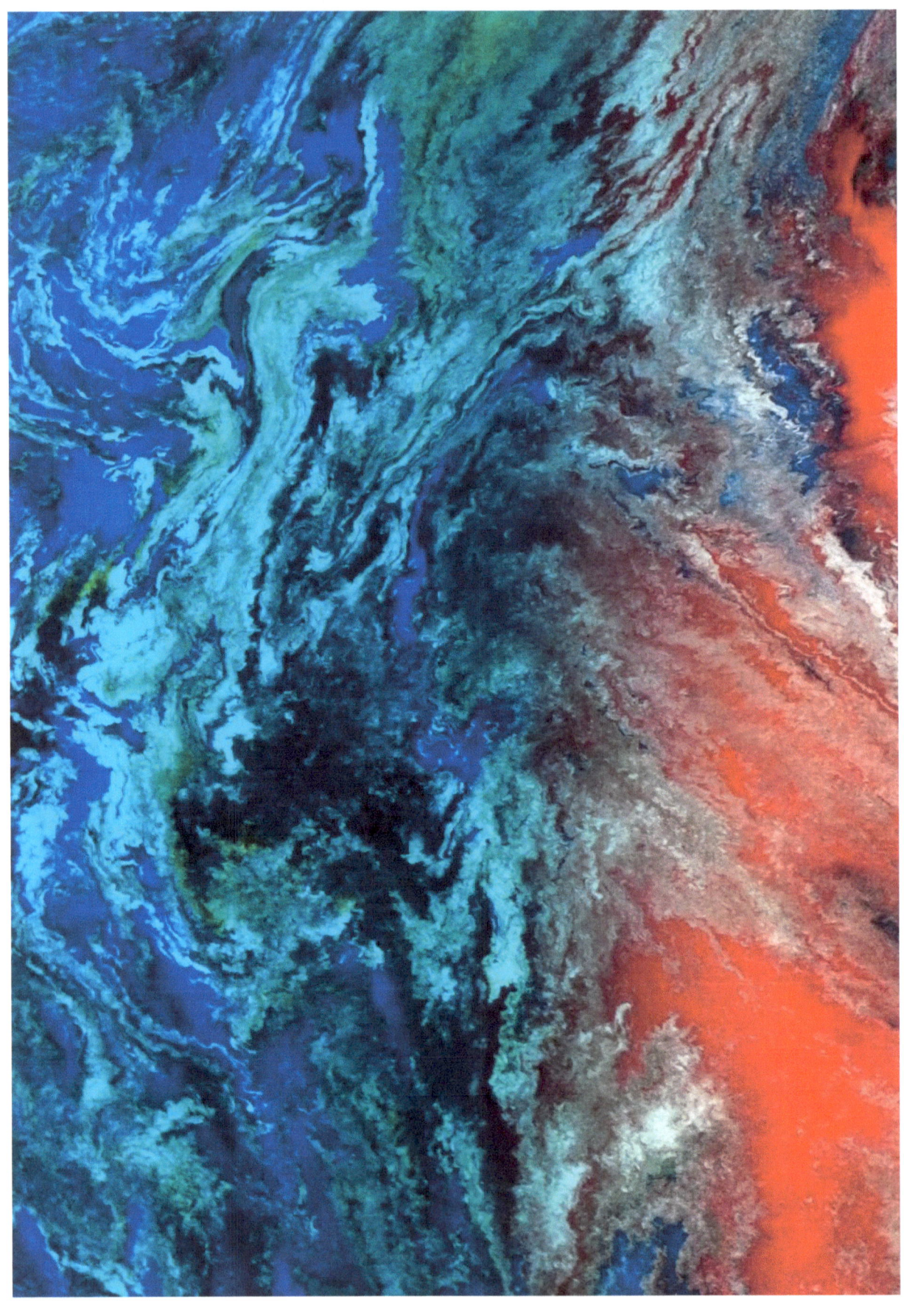

From the Dante – Inferno – Hell series of paintings

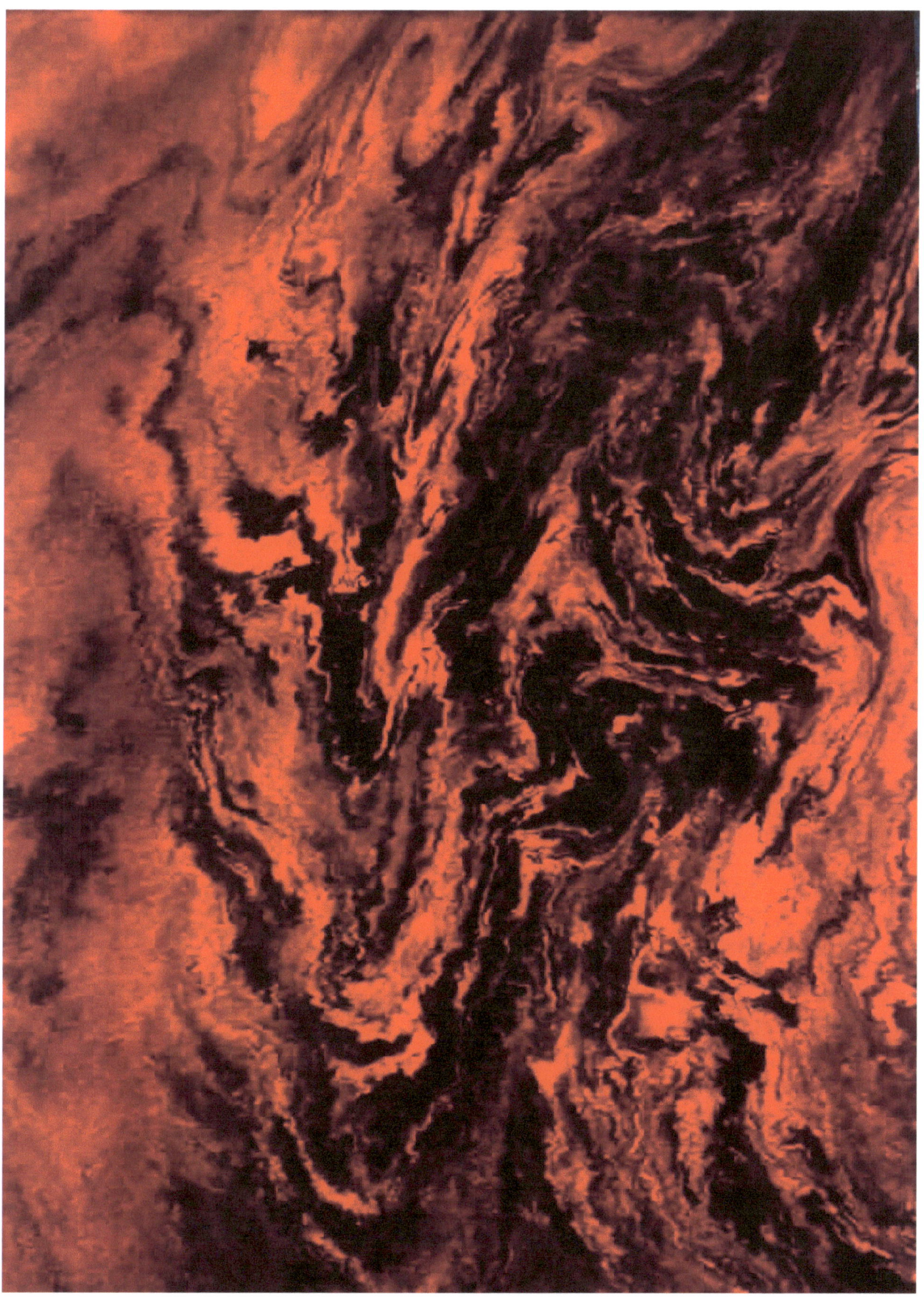

**From the Dante – Inferno – Hell series of paintings**

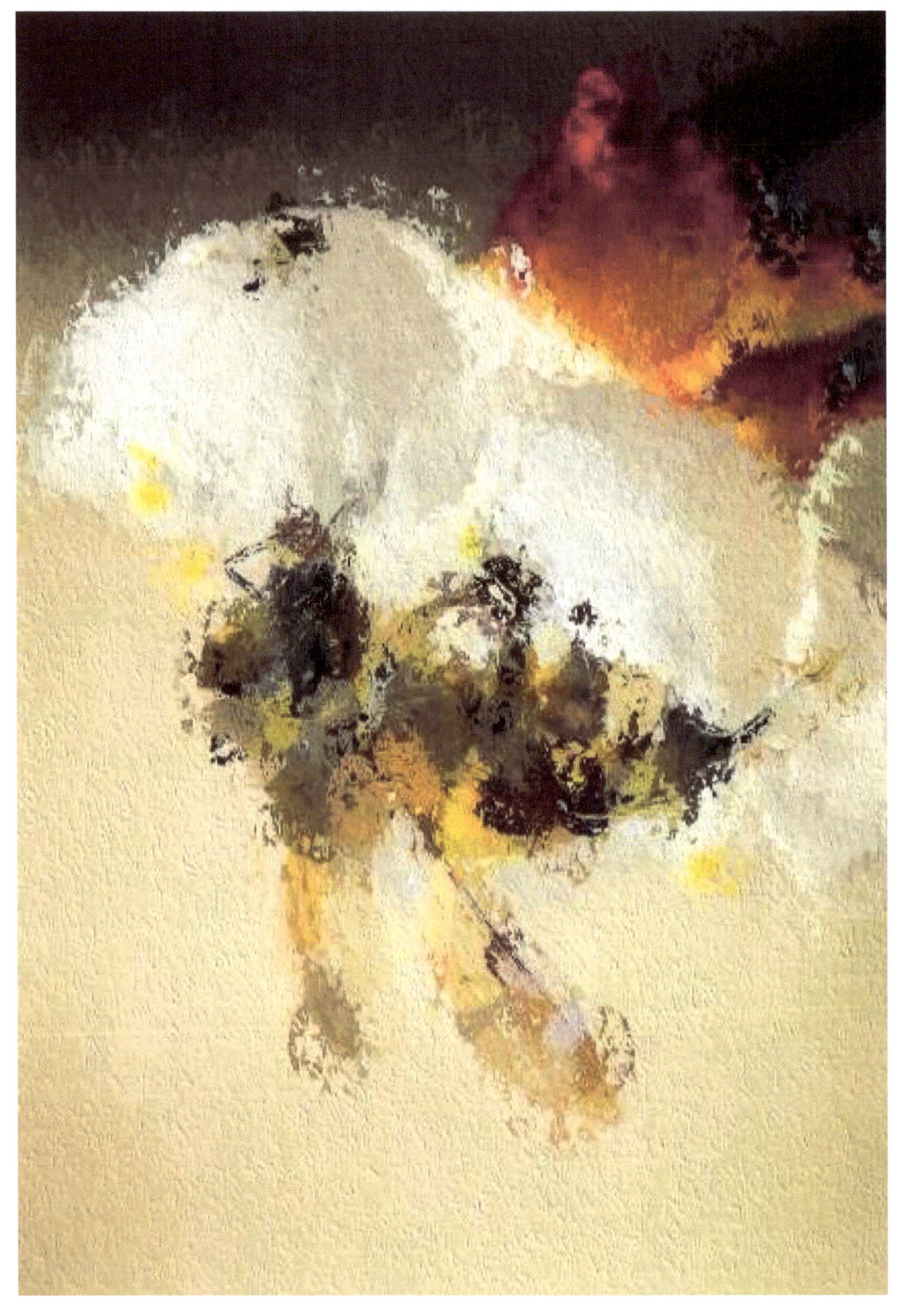

**Pollenating Bee**

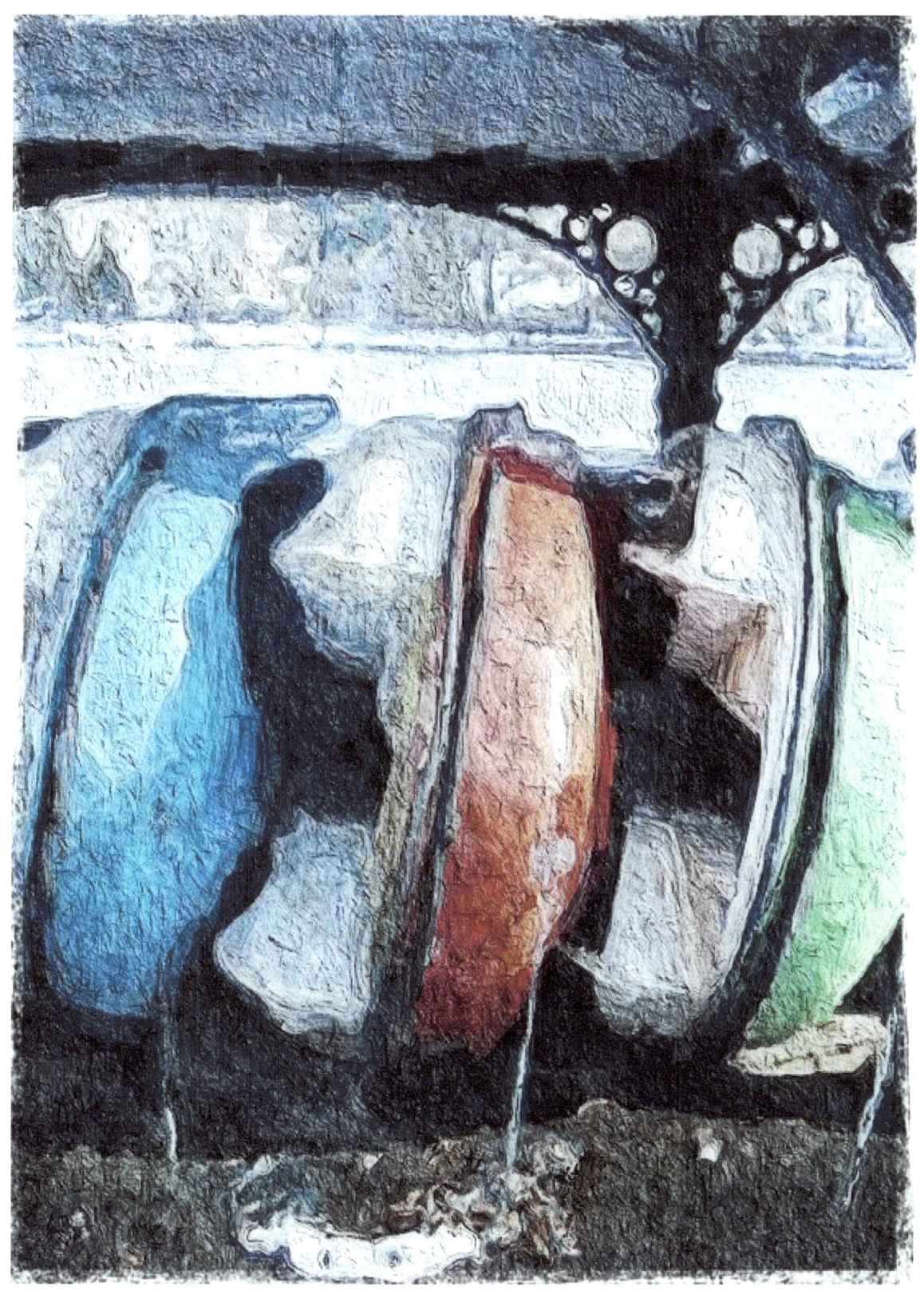

Boats Stacked in a Boatyard
Acrylics on Board

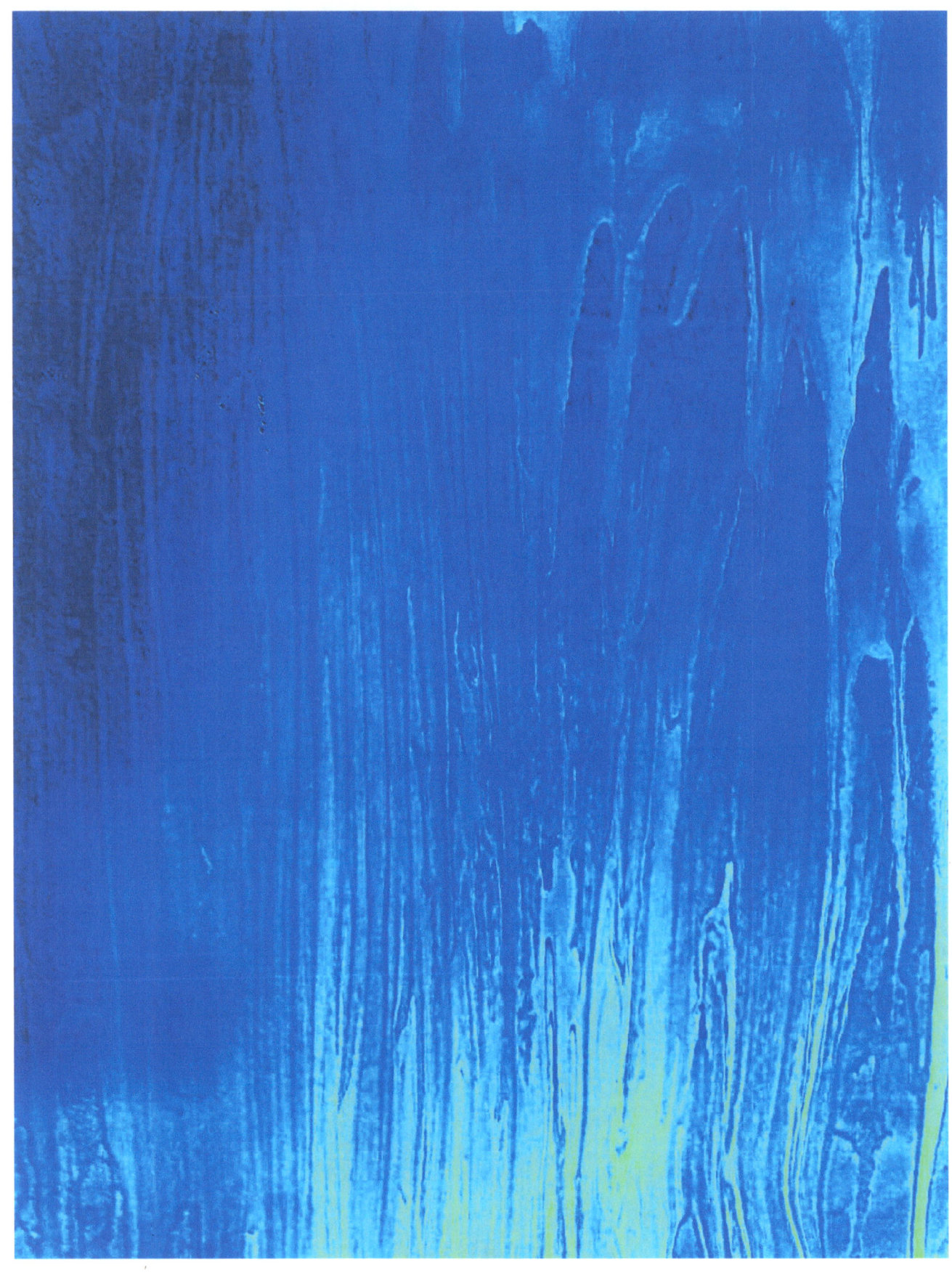

**Blue Emotion**
**Acrylic with Coal Tar Glaze Medium and Gloss Medium**

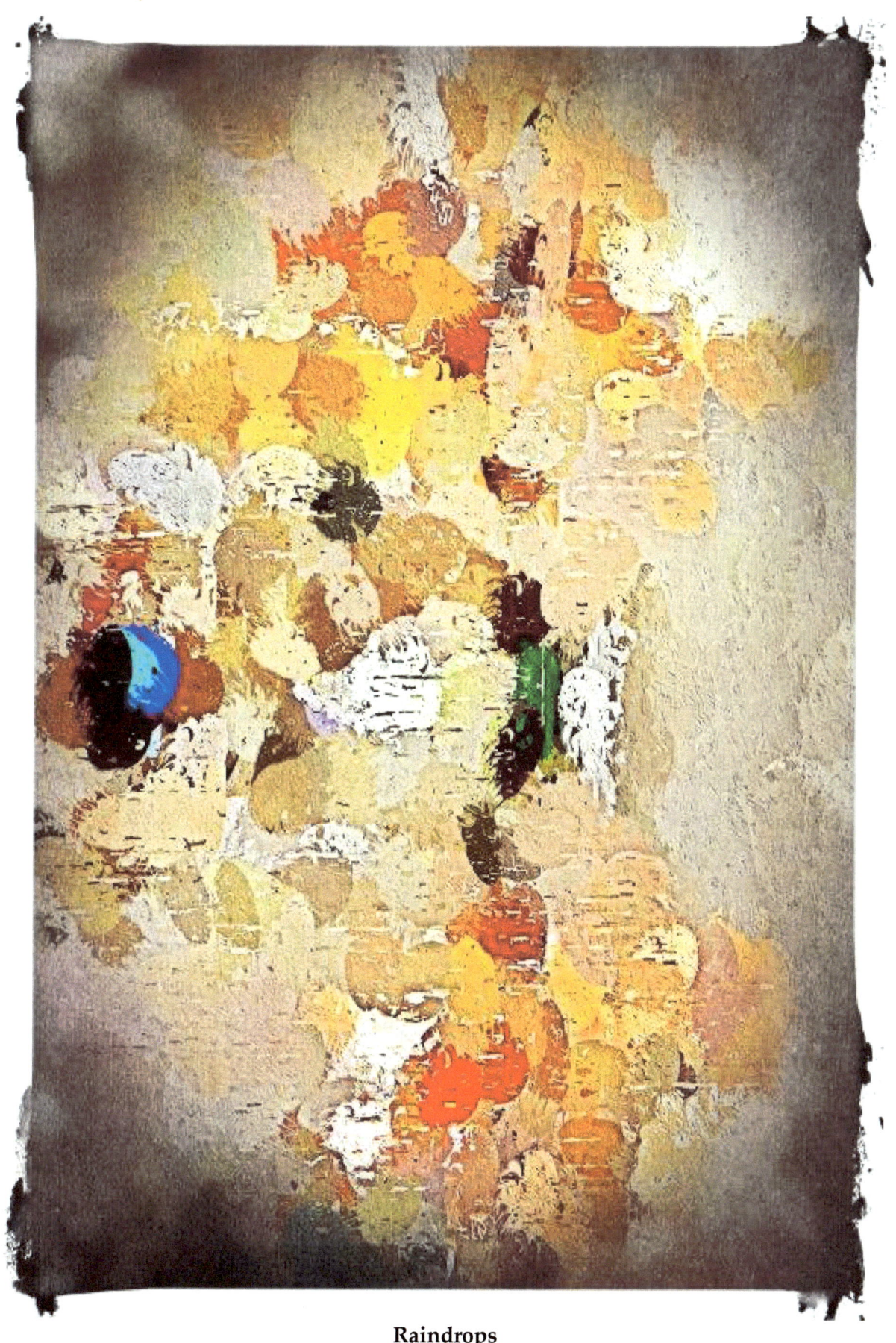

Raindrops

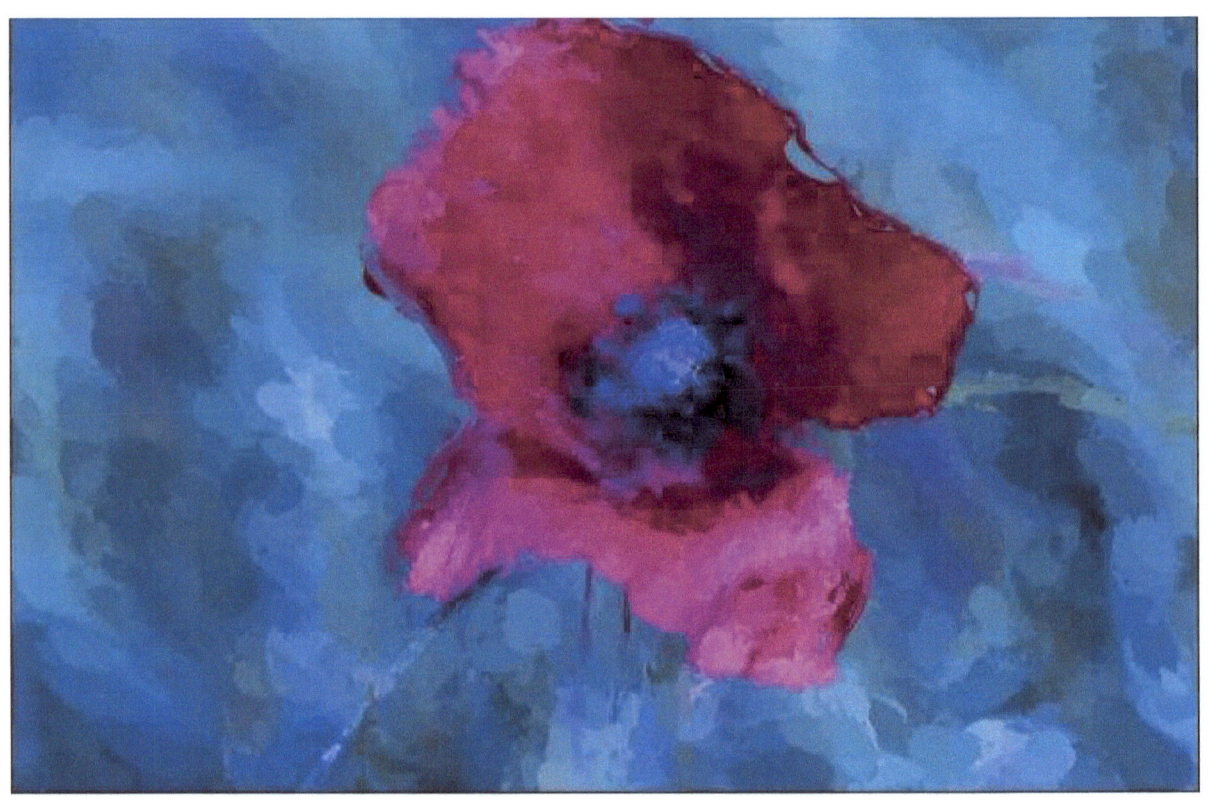

**Poppies #1 & #2**

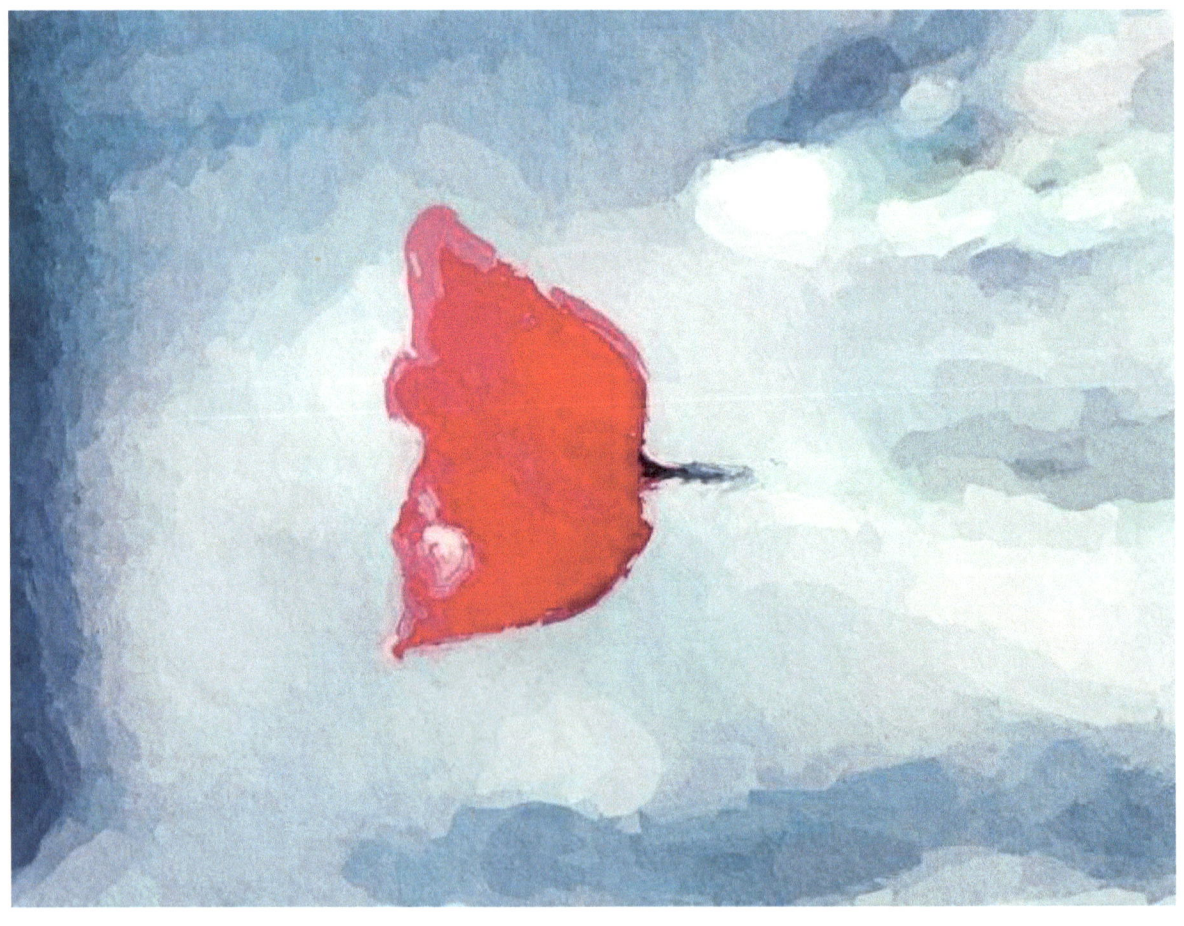

30

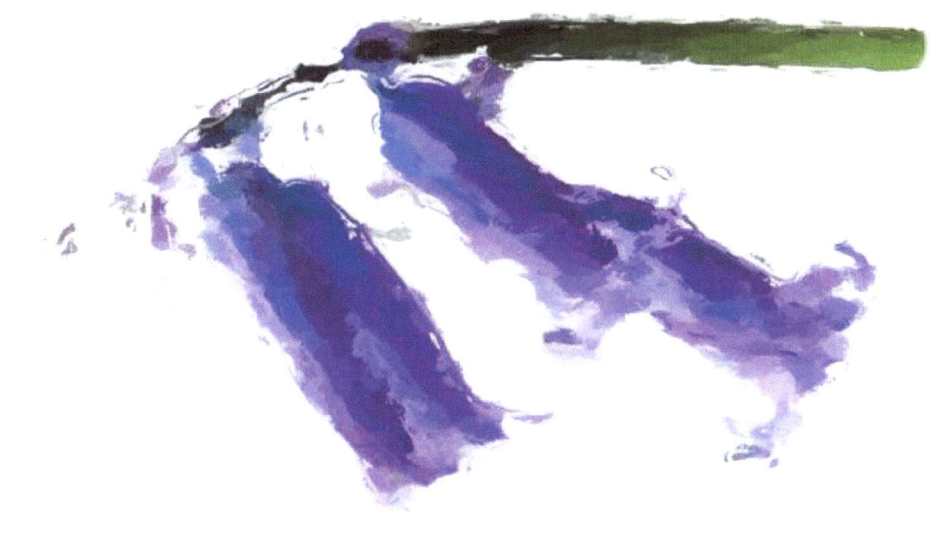

**Bluebells**

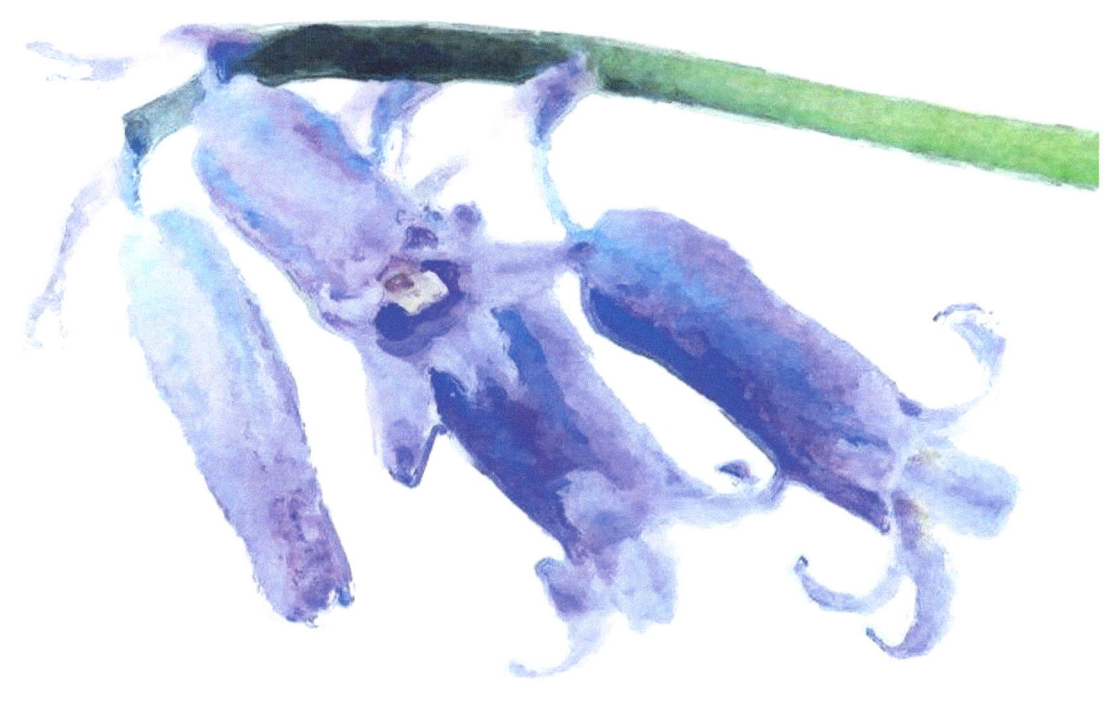

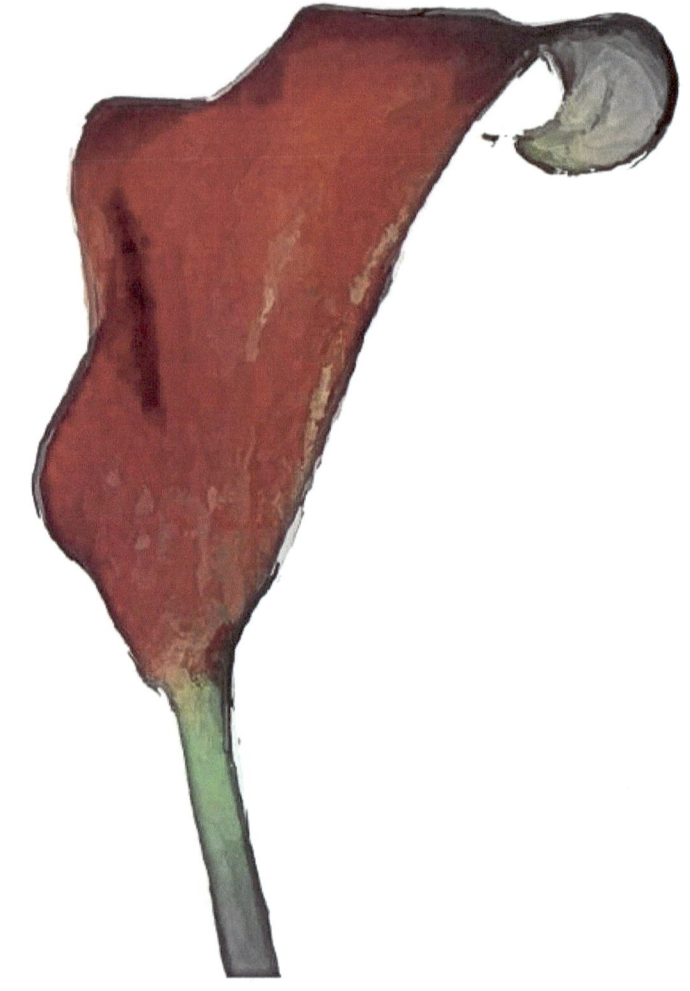

**Single Flower**

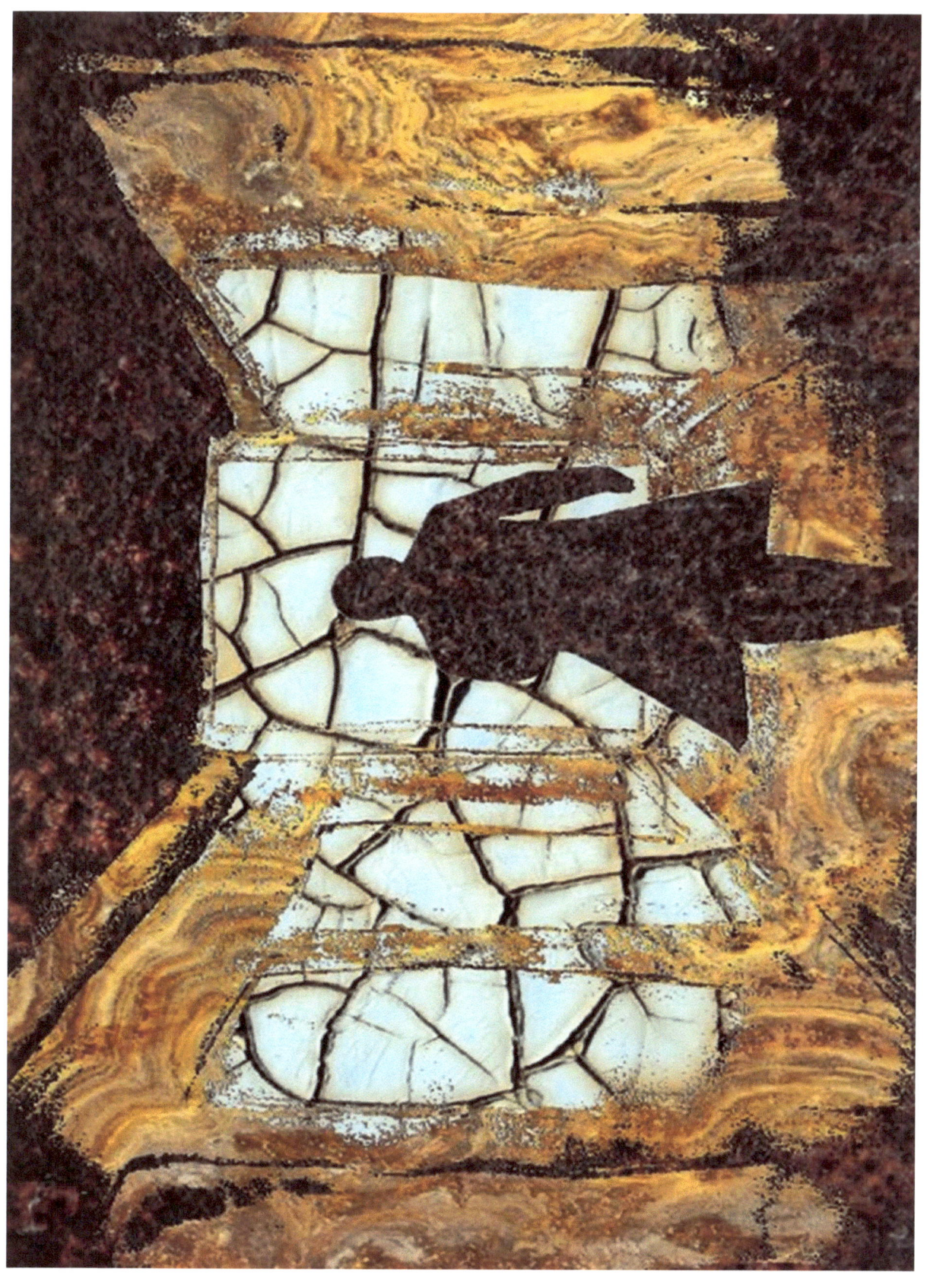

**The Step Forwards**
From the Bataille's Dog series of paintings

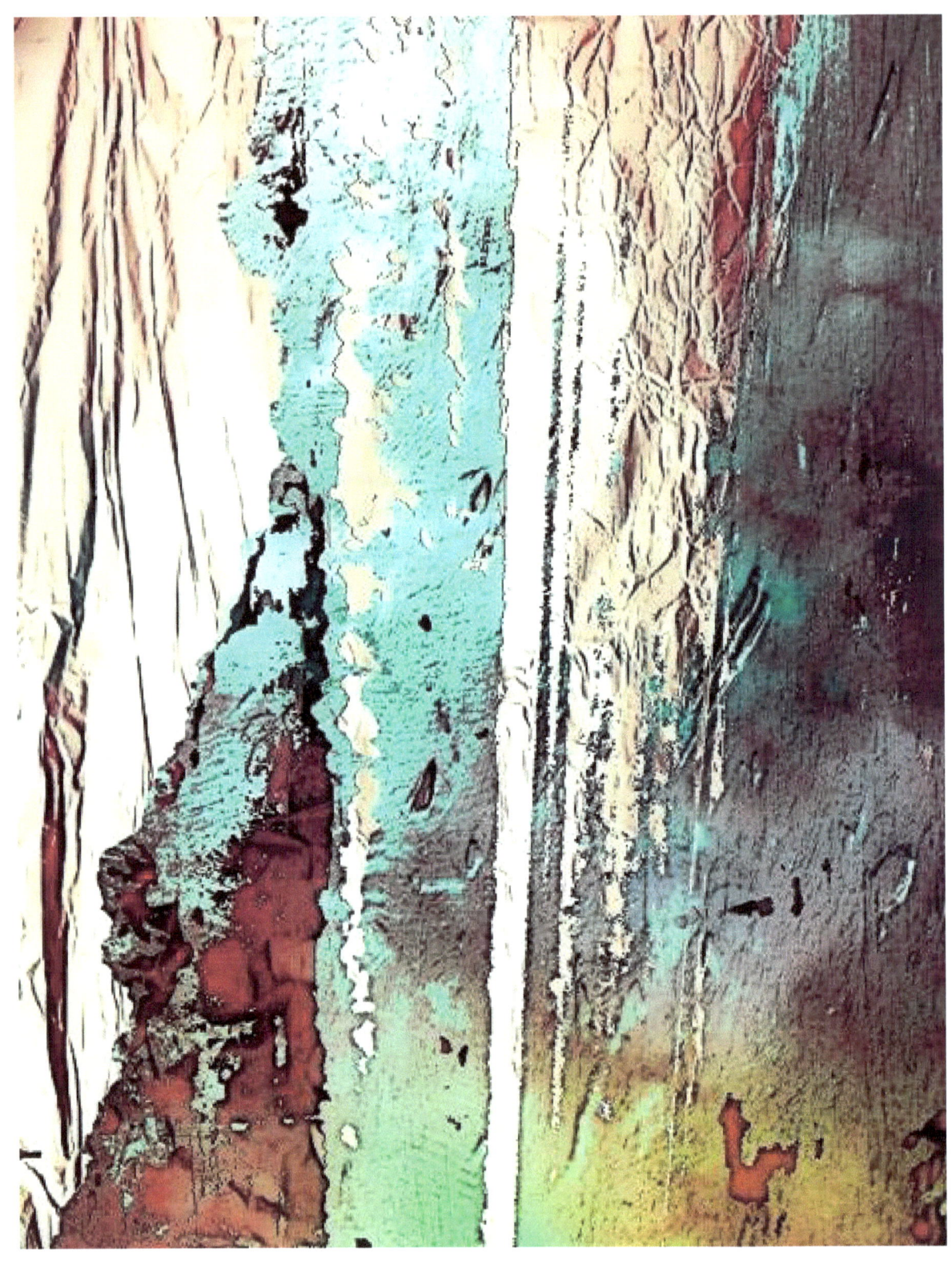

From the Bataille's Dog series of paintings

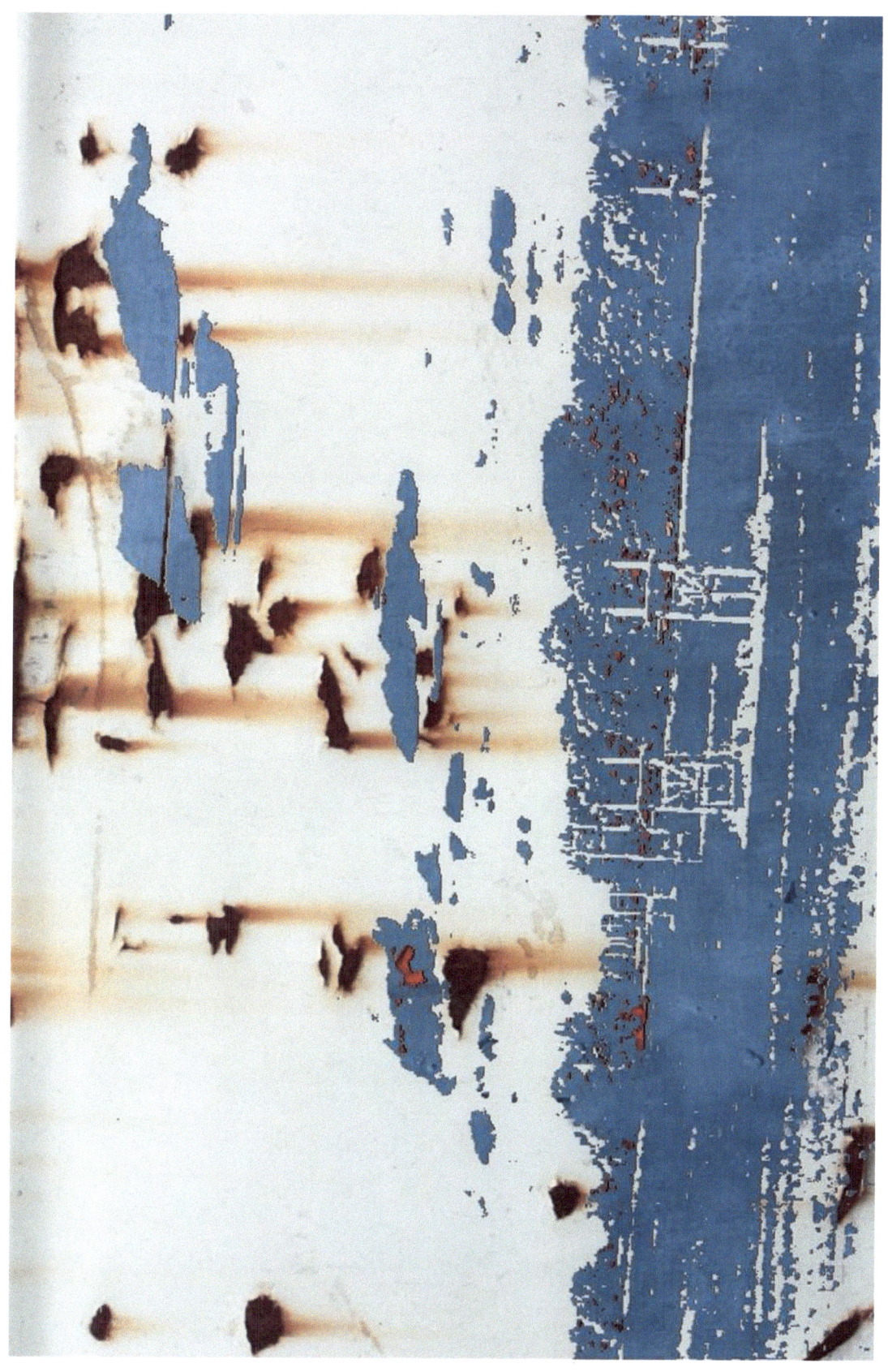

**From the Bataille's Dog series of paintings**

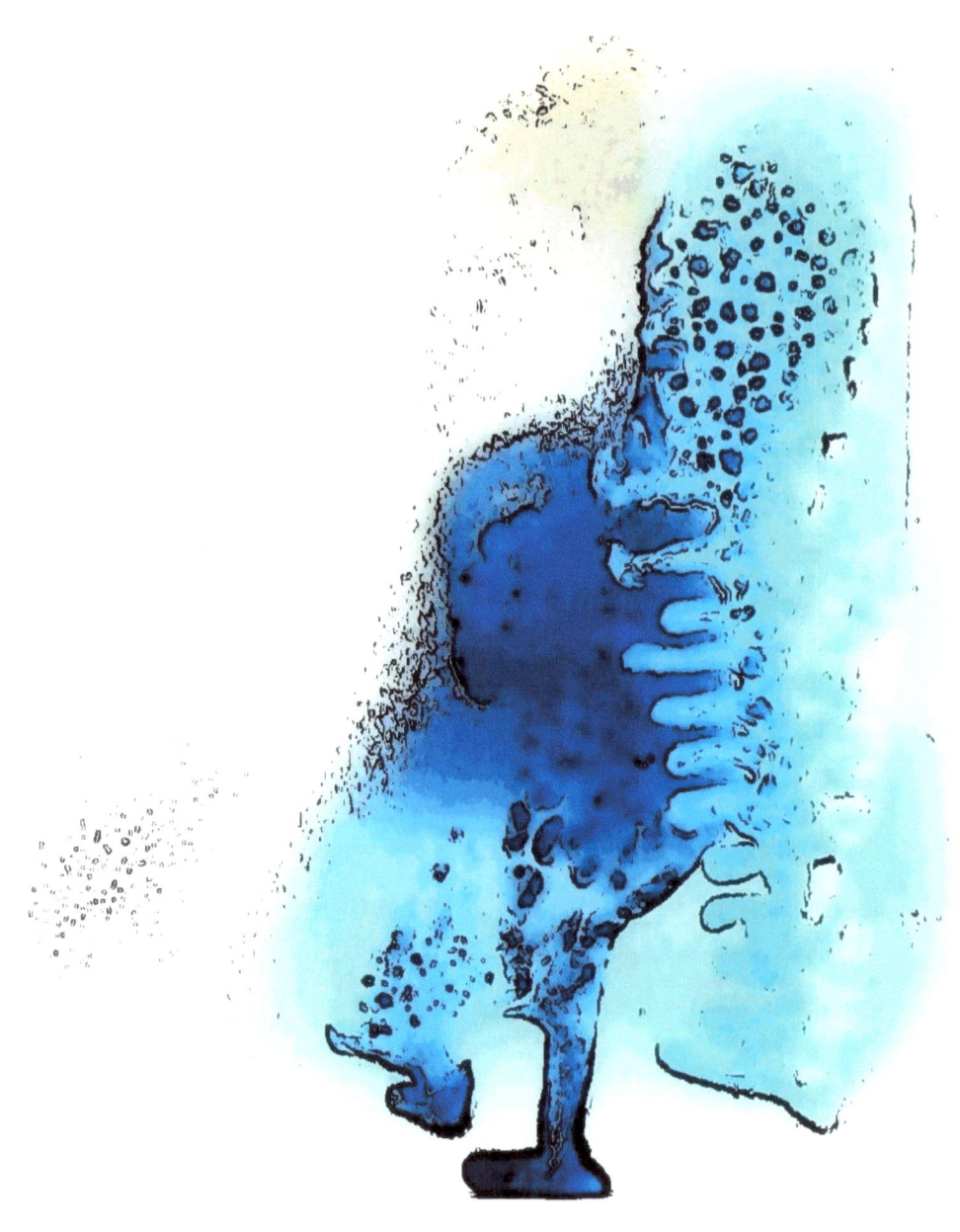

**From the Bataille's Dog series of paintings**

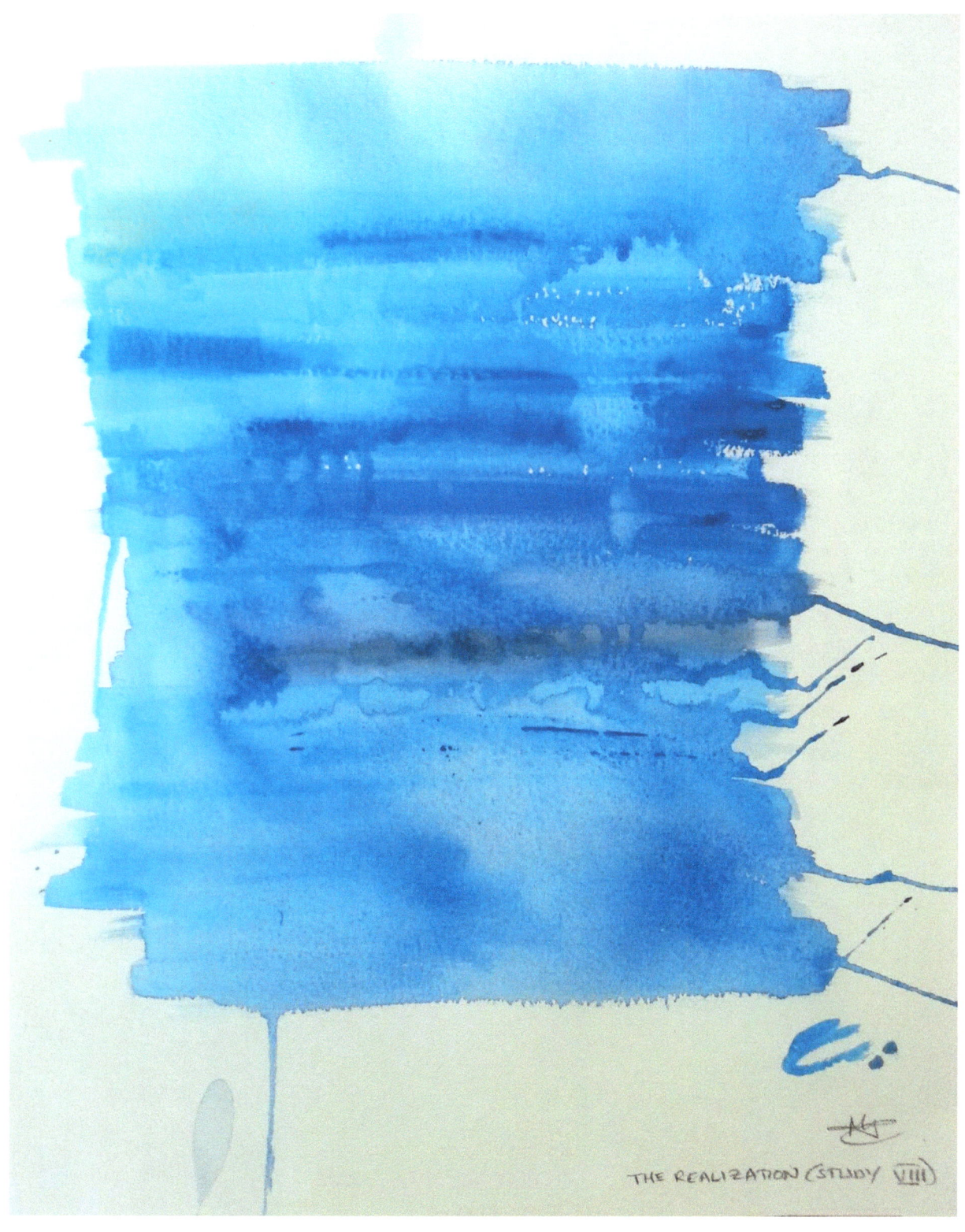

**The Realization**
**Proof from The Faustus Series of Paintings**

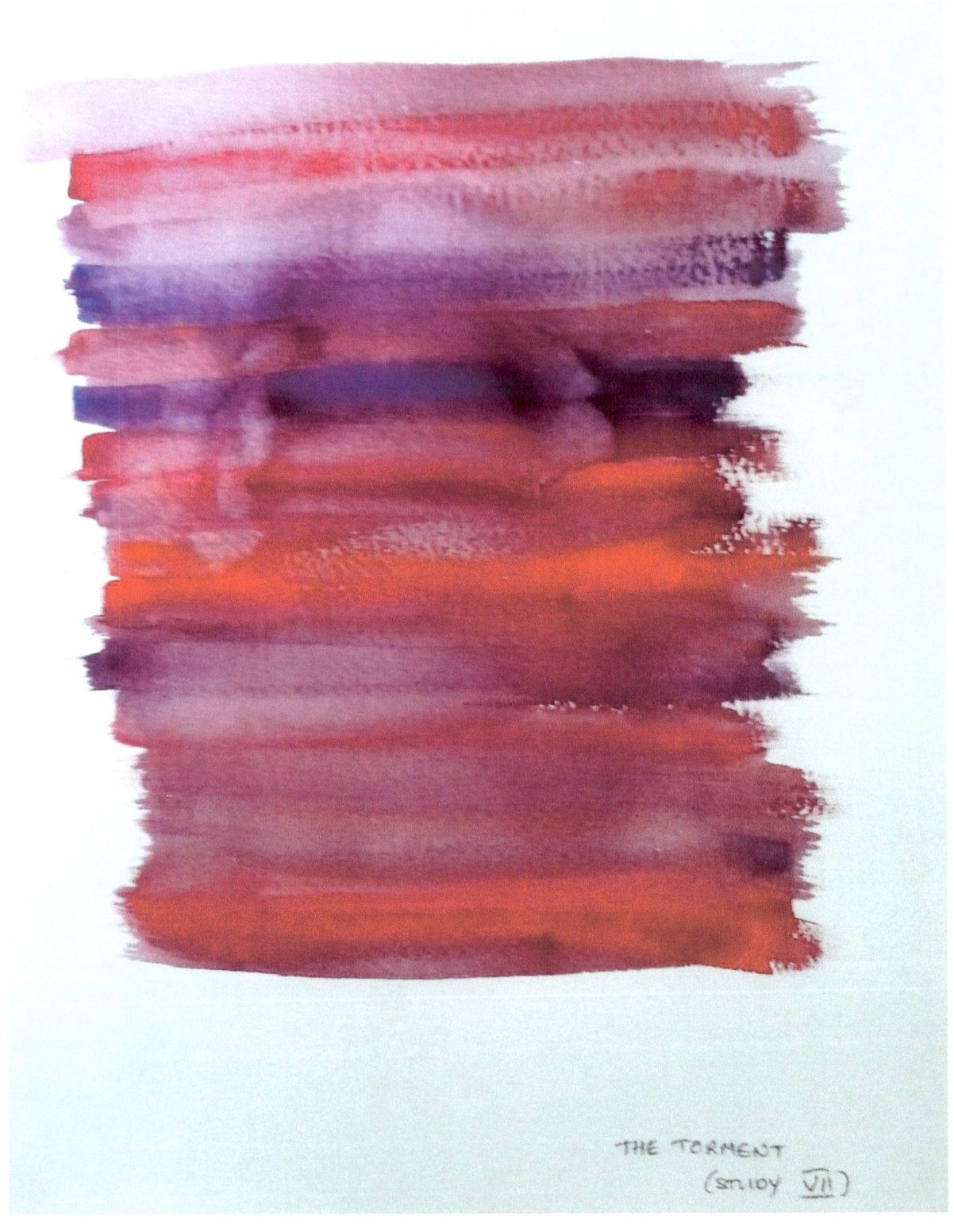

**The Torment**
**Proof from The Faustus series of paintings**

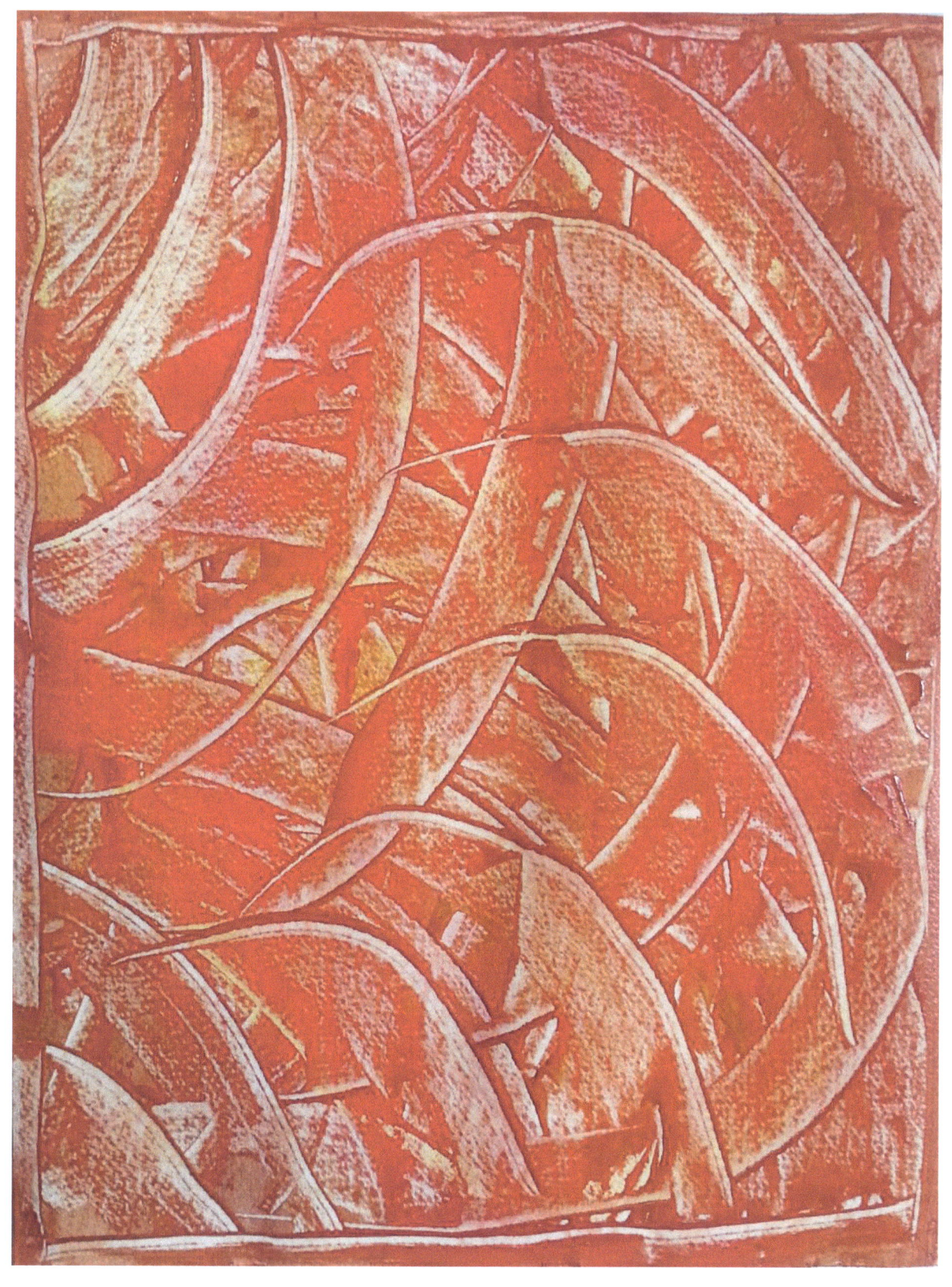

**Descent**
**From The Faustus series of paintings**

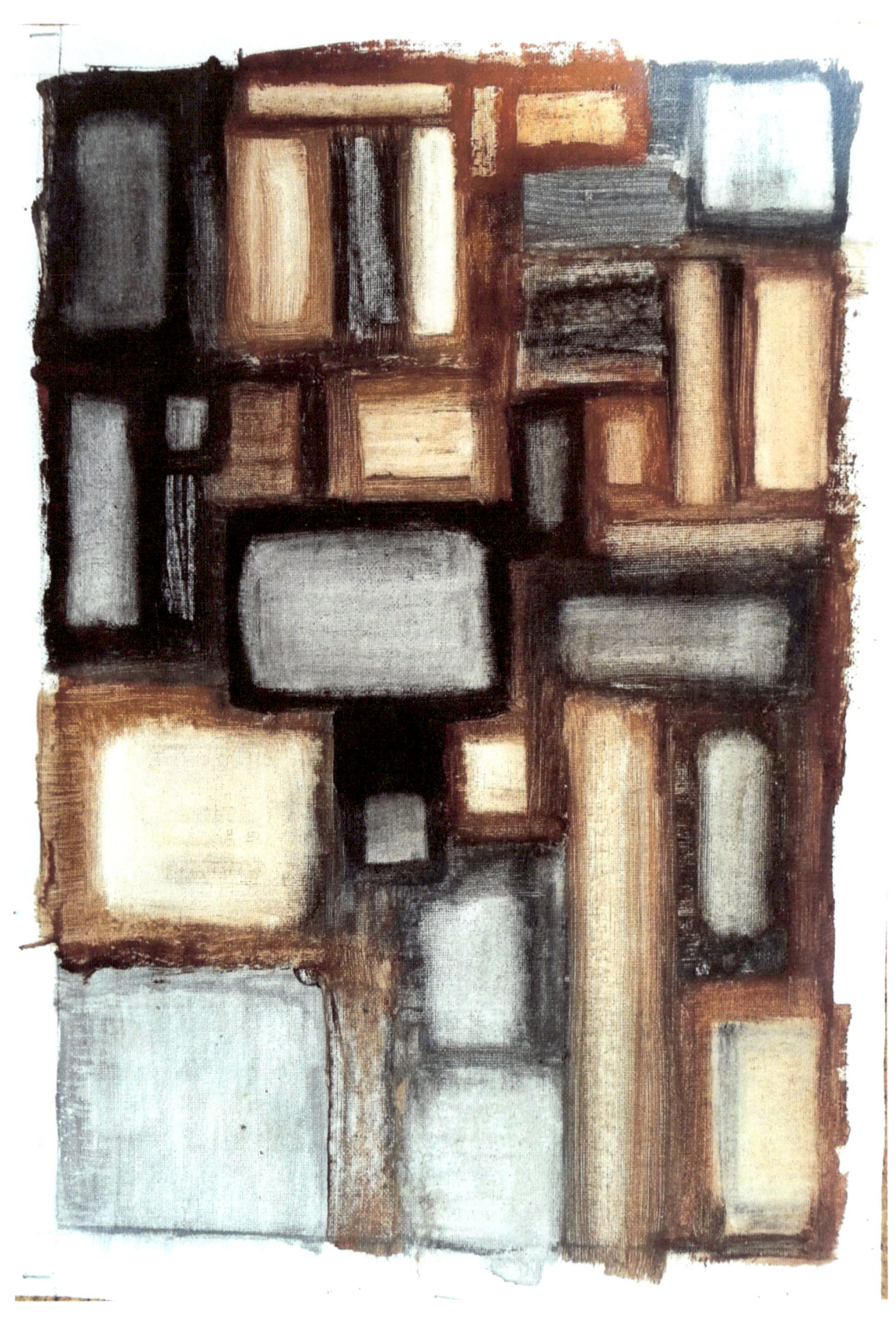

**Order #21**

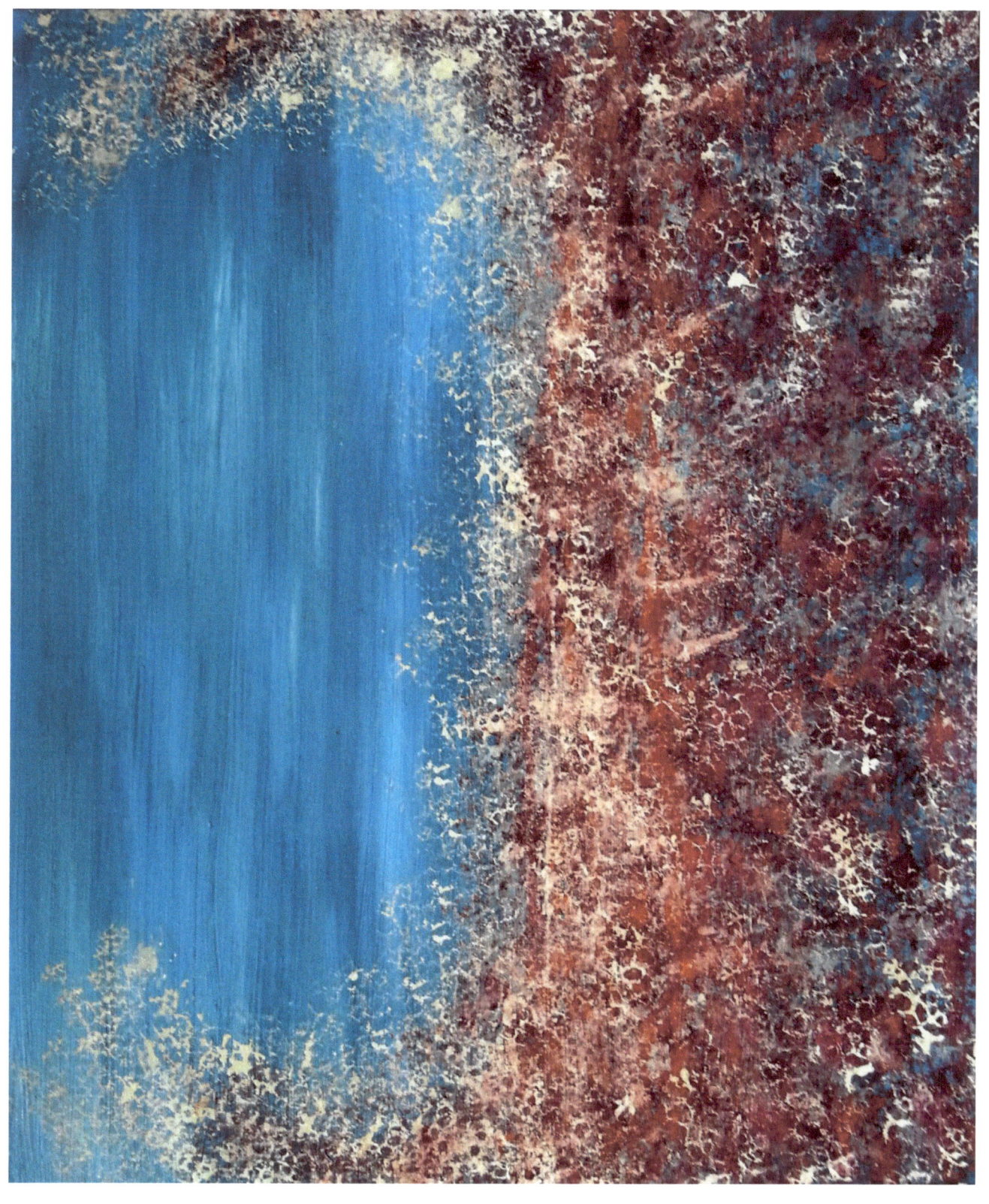

**Untitled #21**

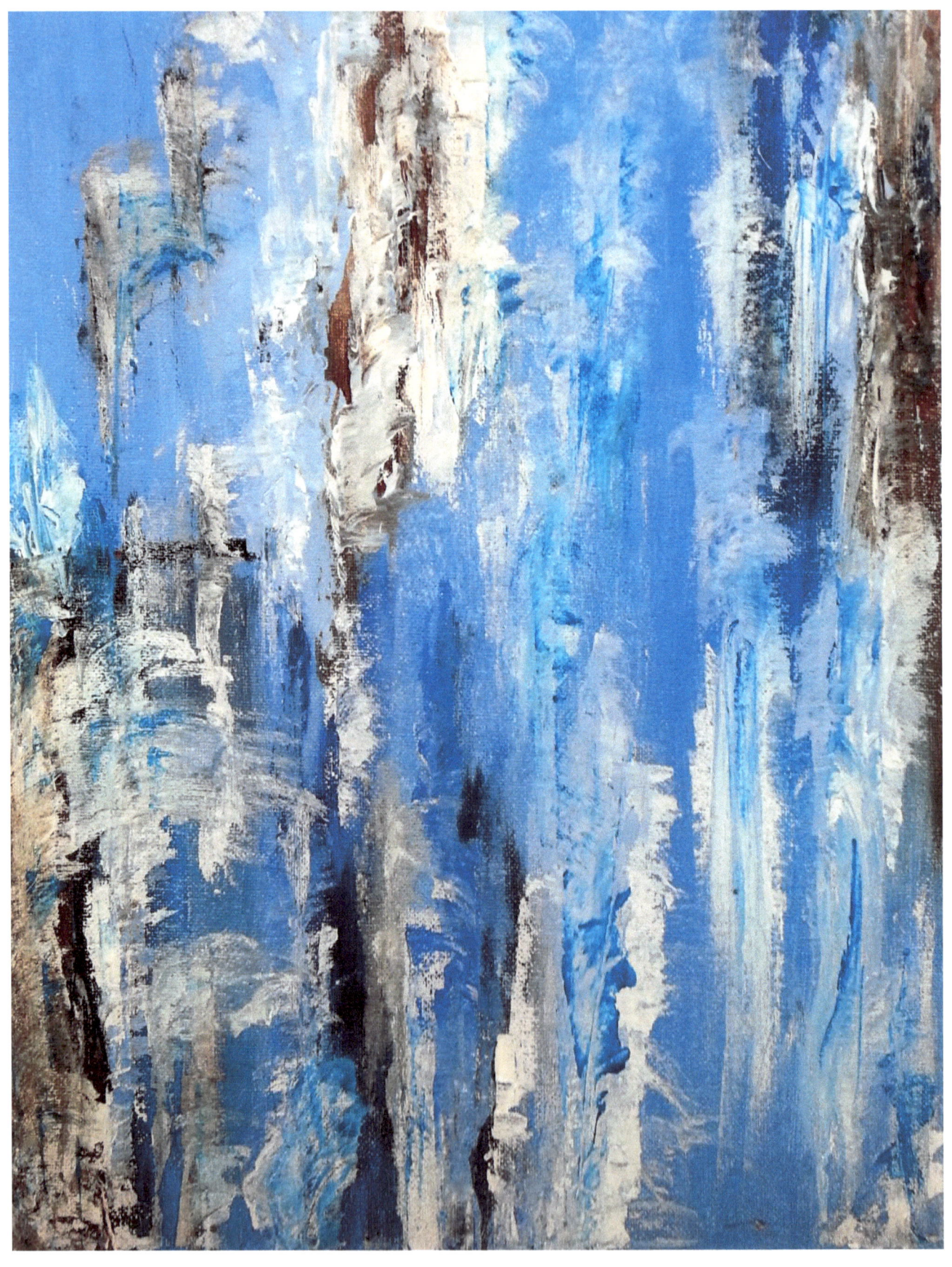

**Untitled #22**

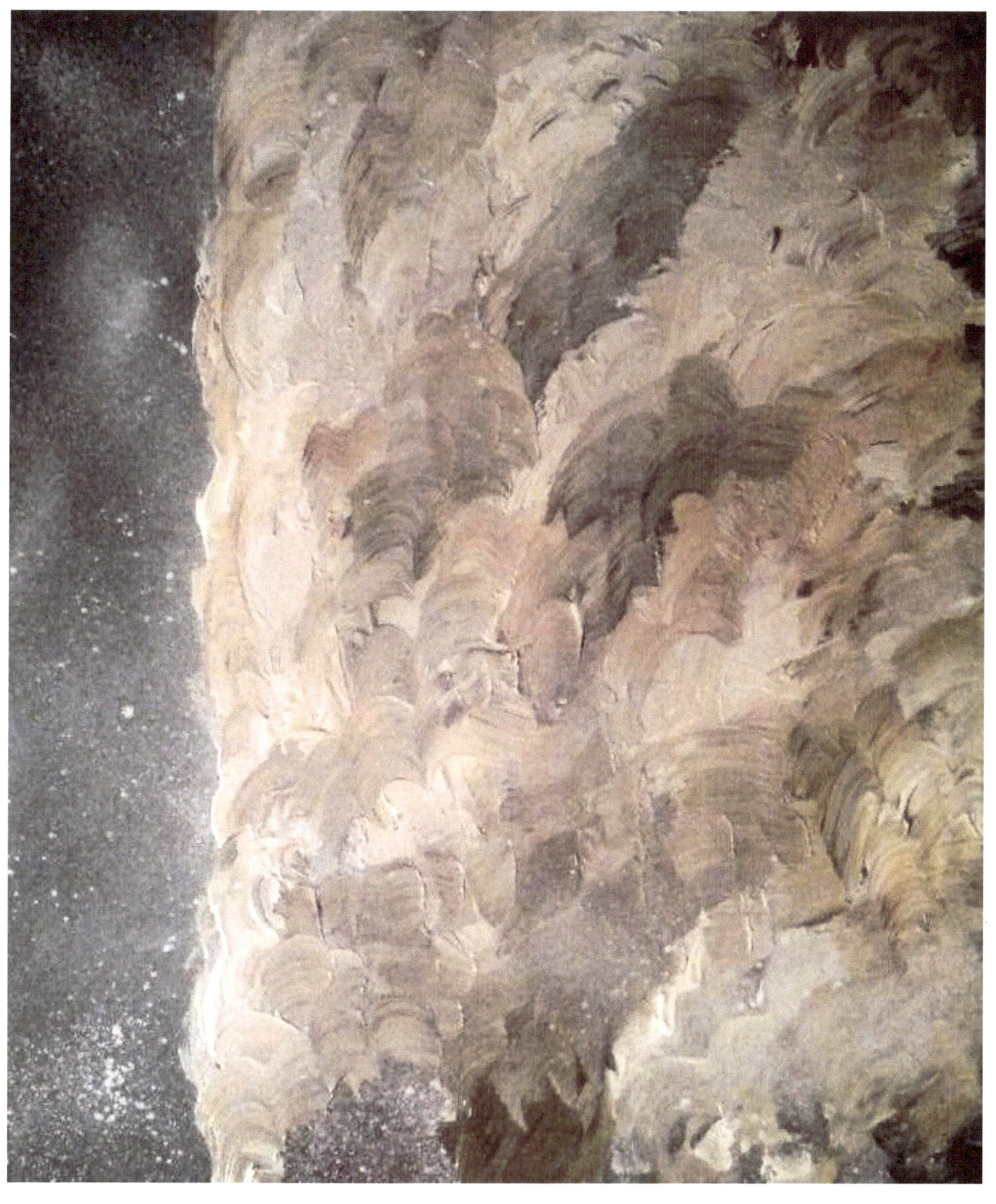

**Waterfall**

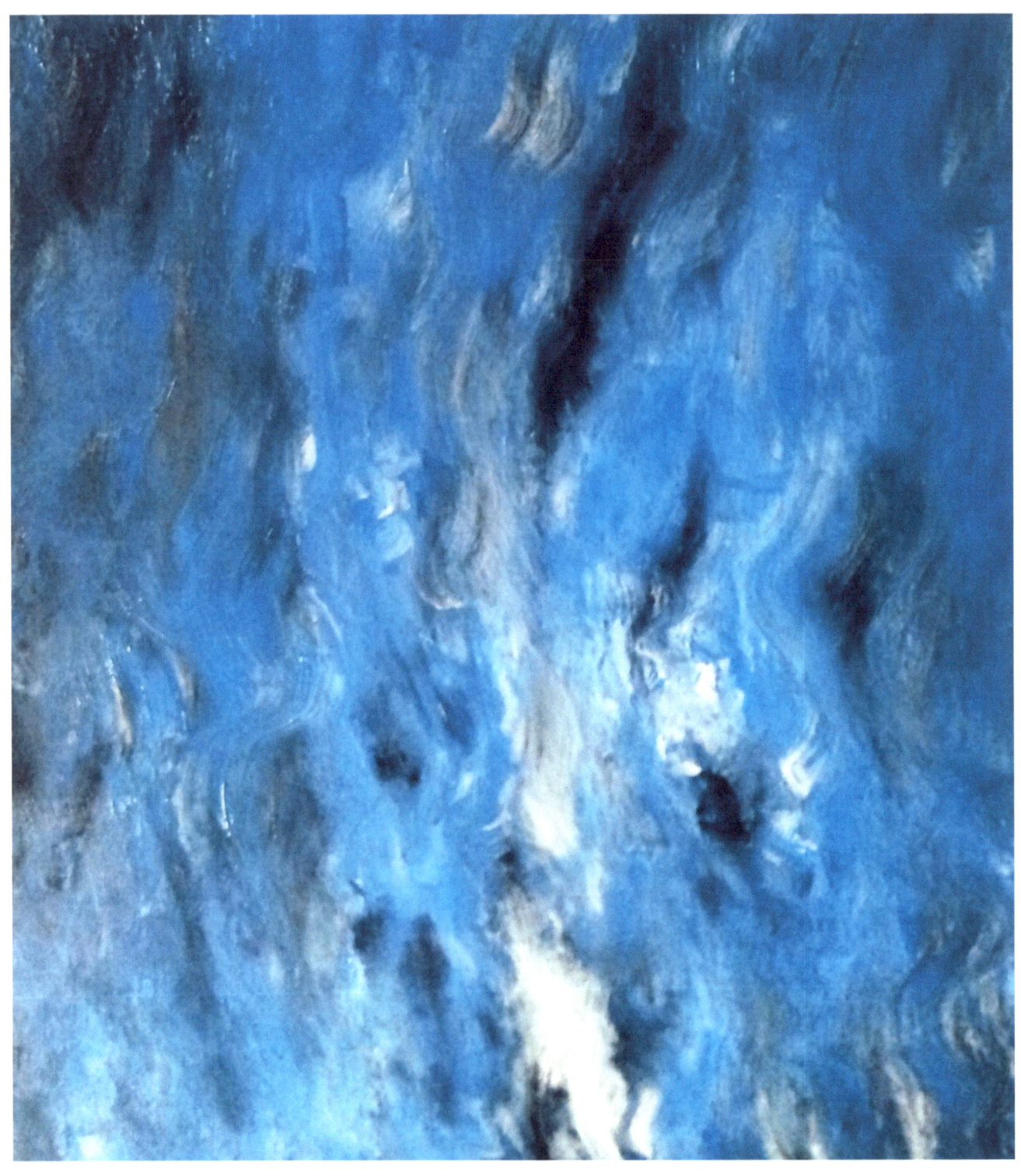

Seascape

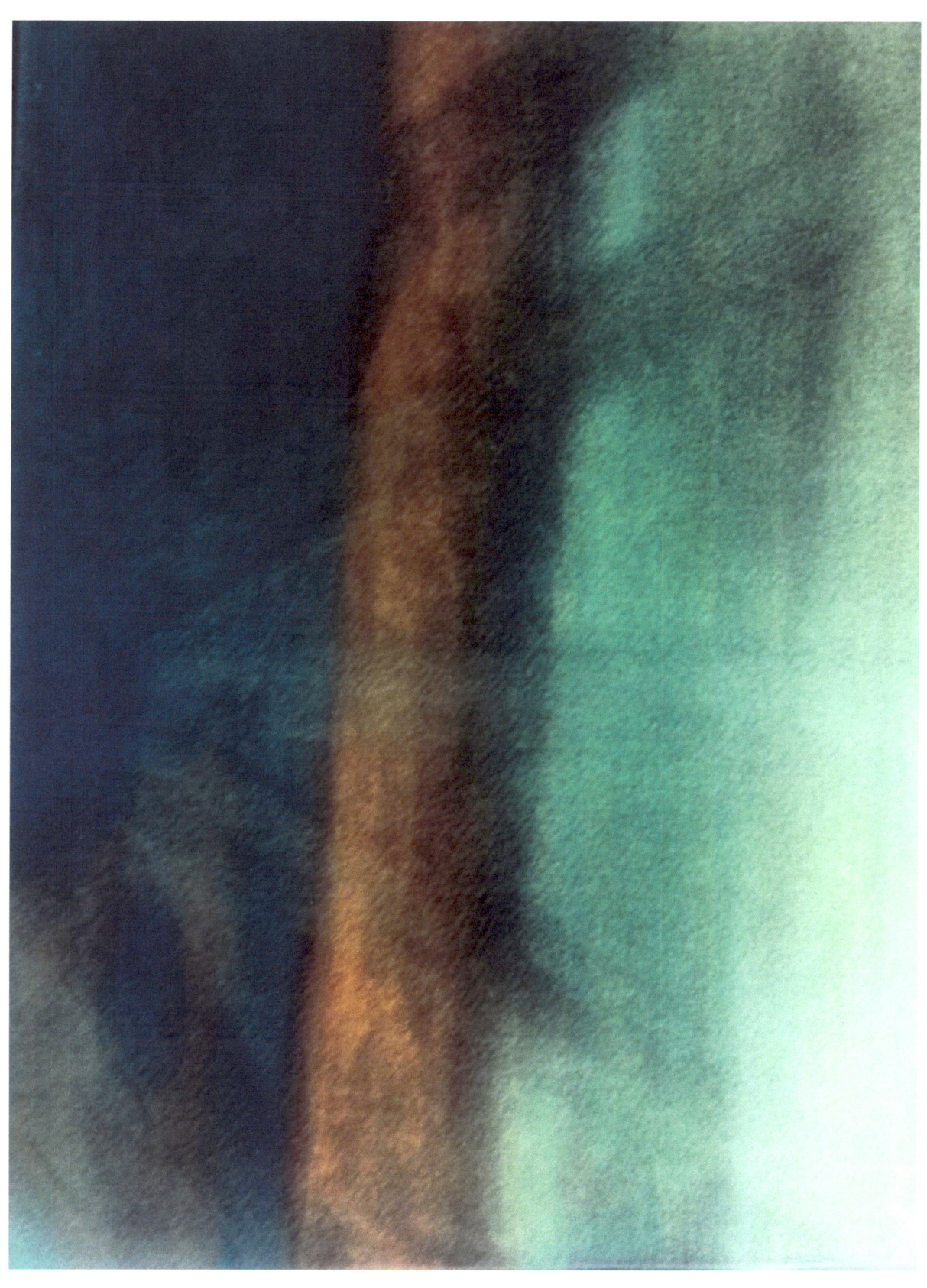

**Sun on underwater log**
**(seen from the log's perspective – looking up)**

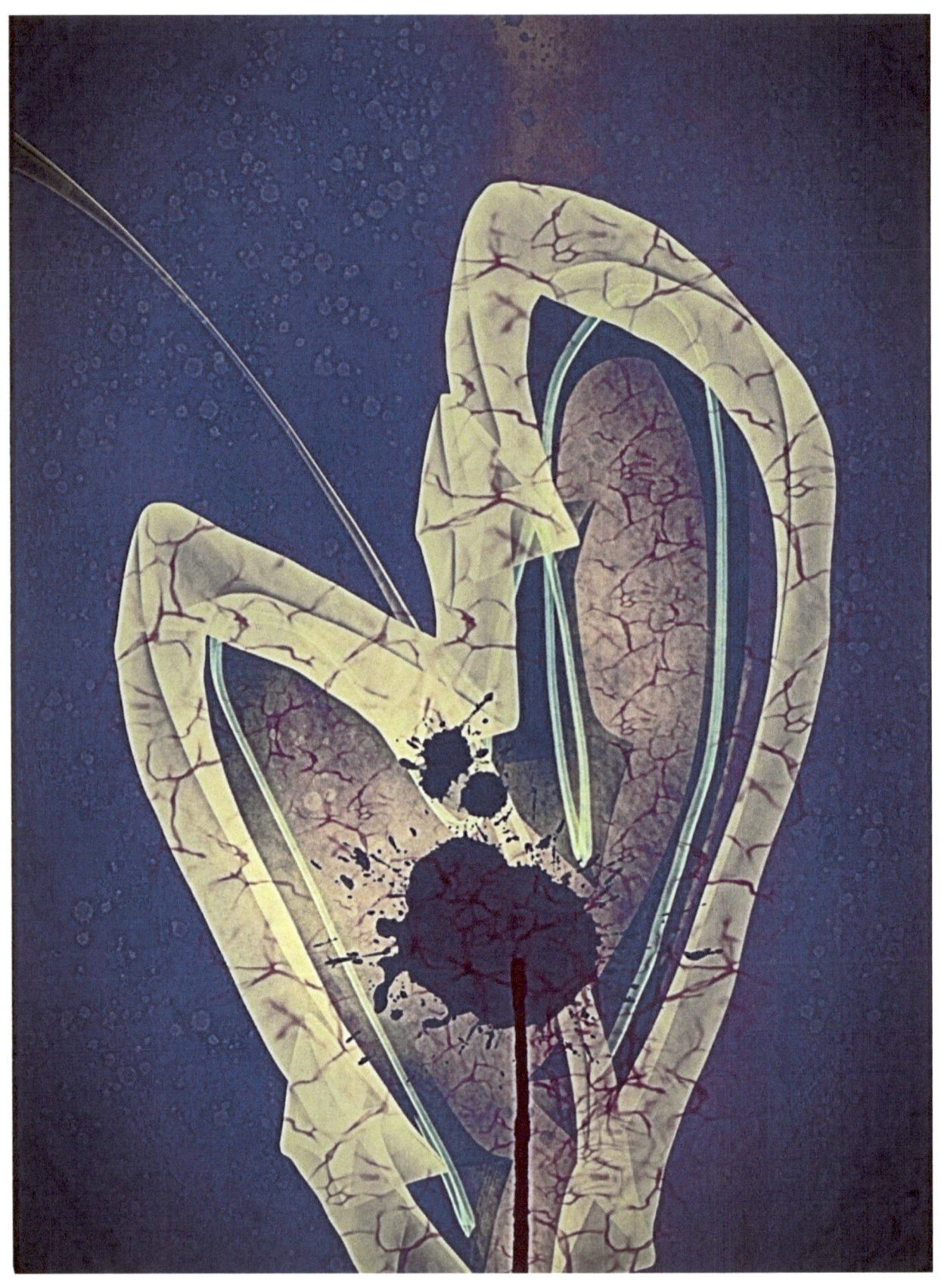

**Bleeding Heart #3**

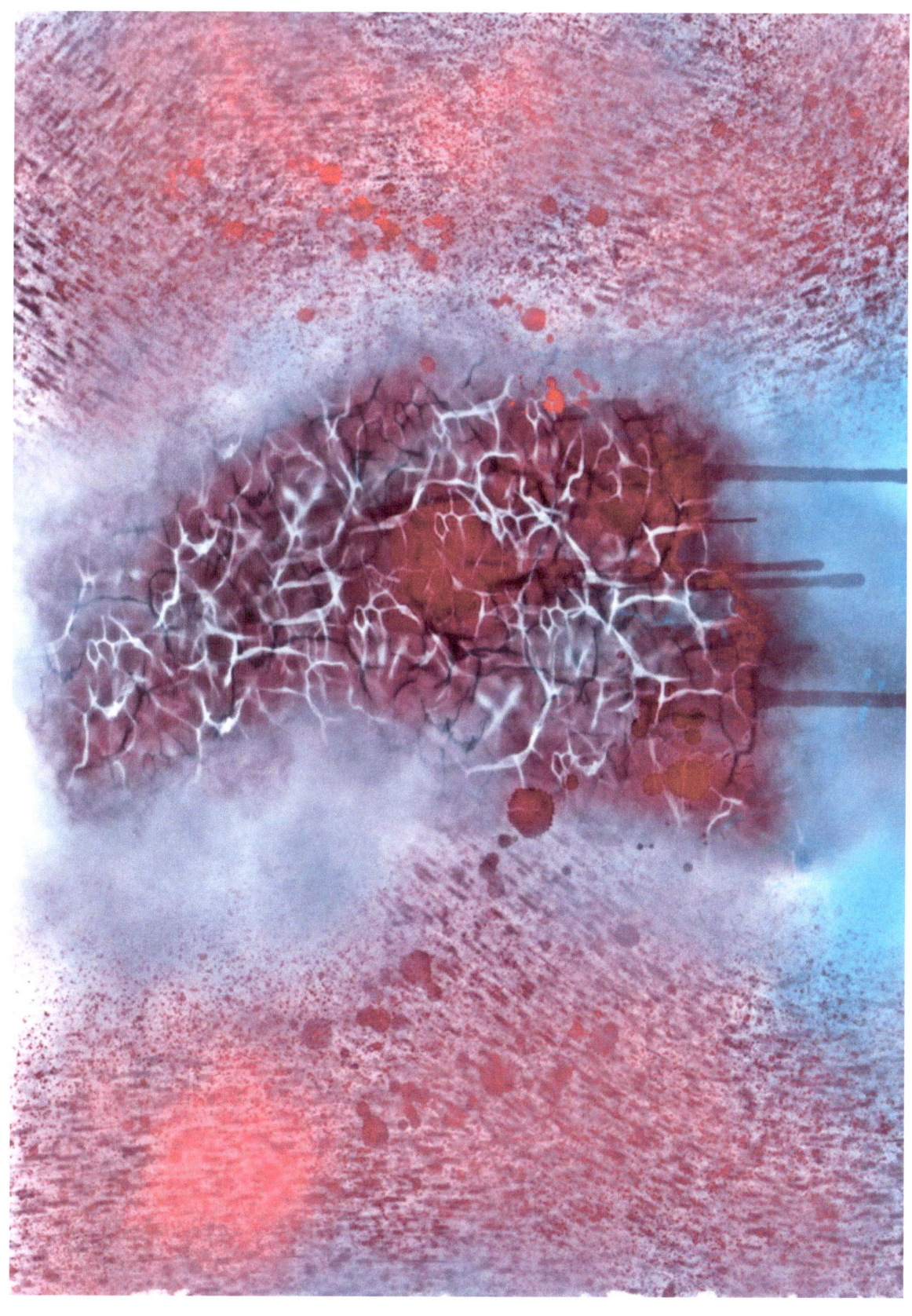

**Bleeding Heart #5**

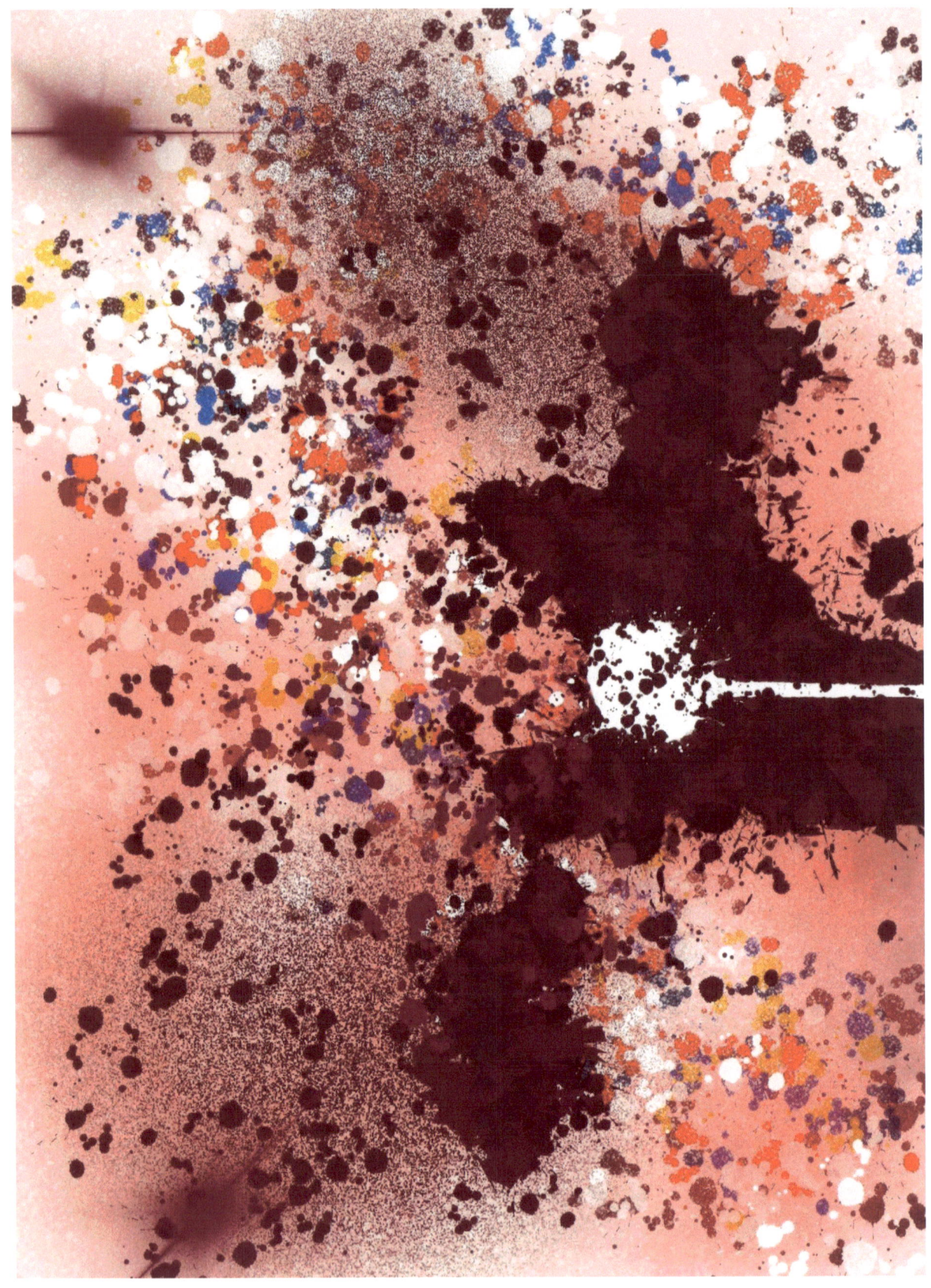

**Bleeding Heart #7**

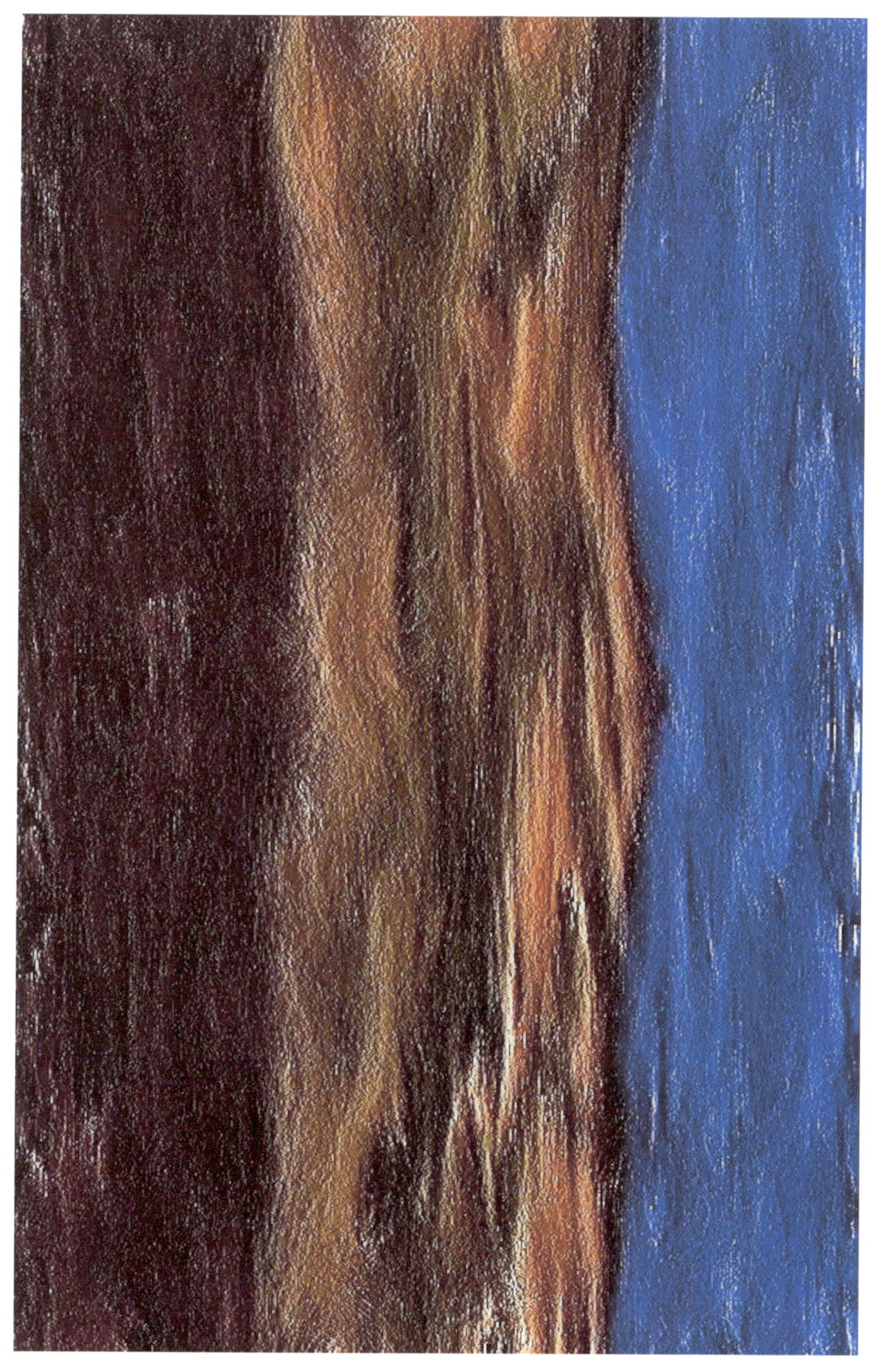

**Random Seas**
**Marbled Foil with Enamels**

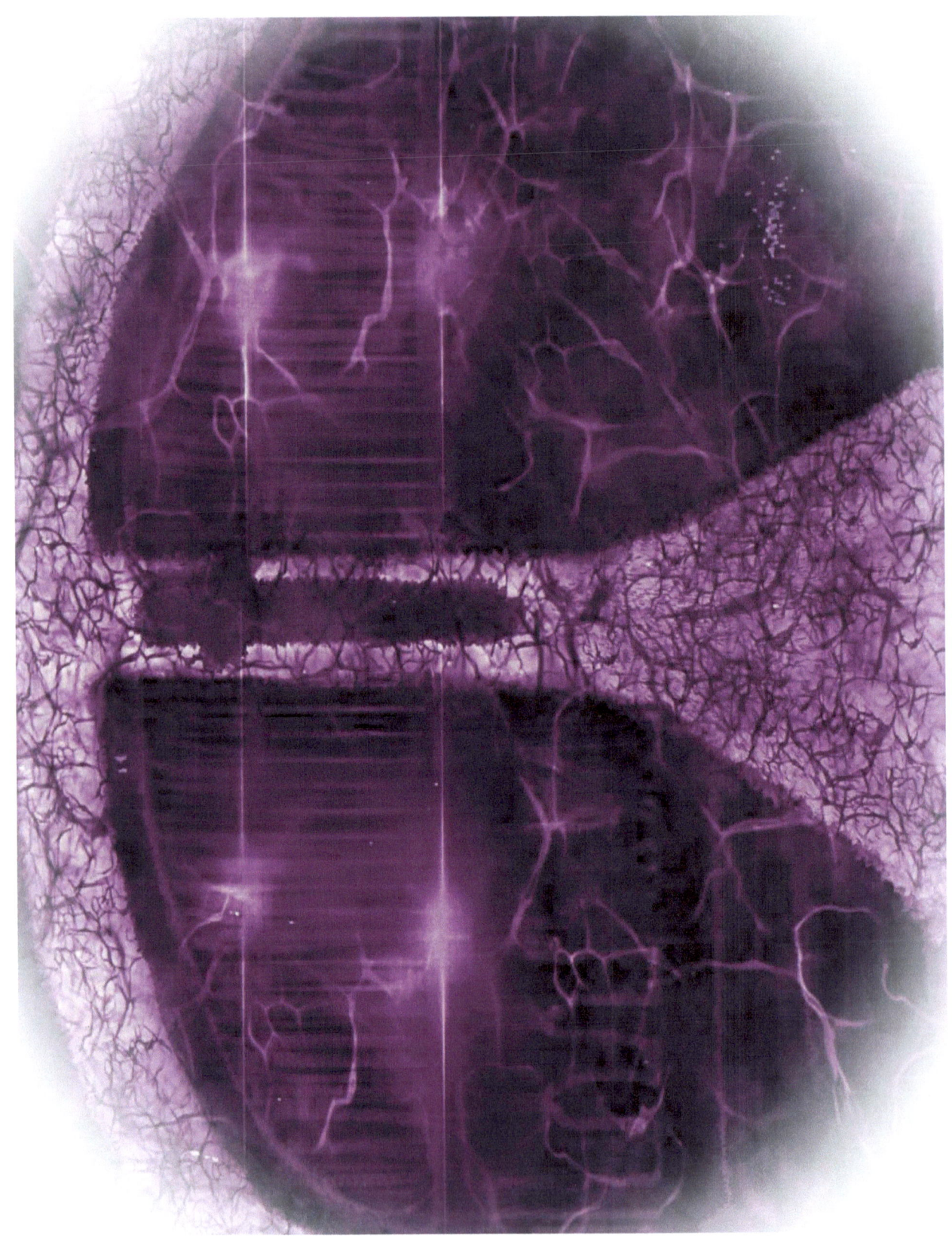

**Metropolis**
**(Inspired by Fritz Lang's 1927 film Metropolis)**

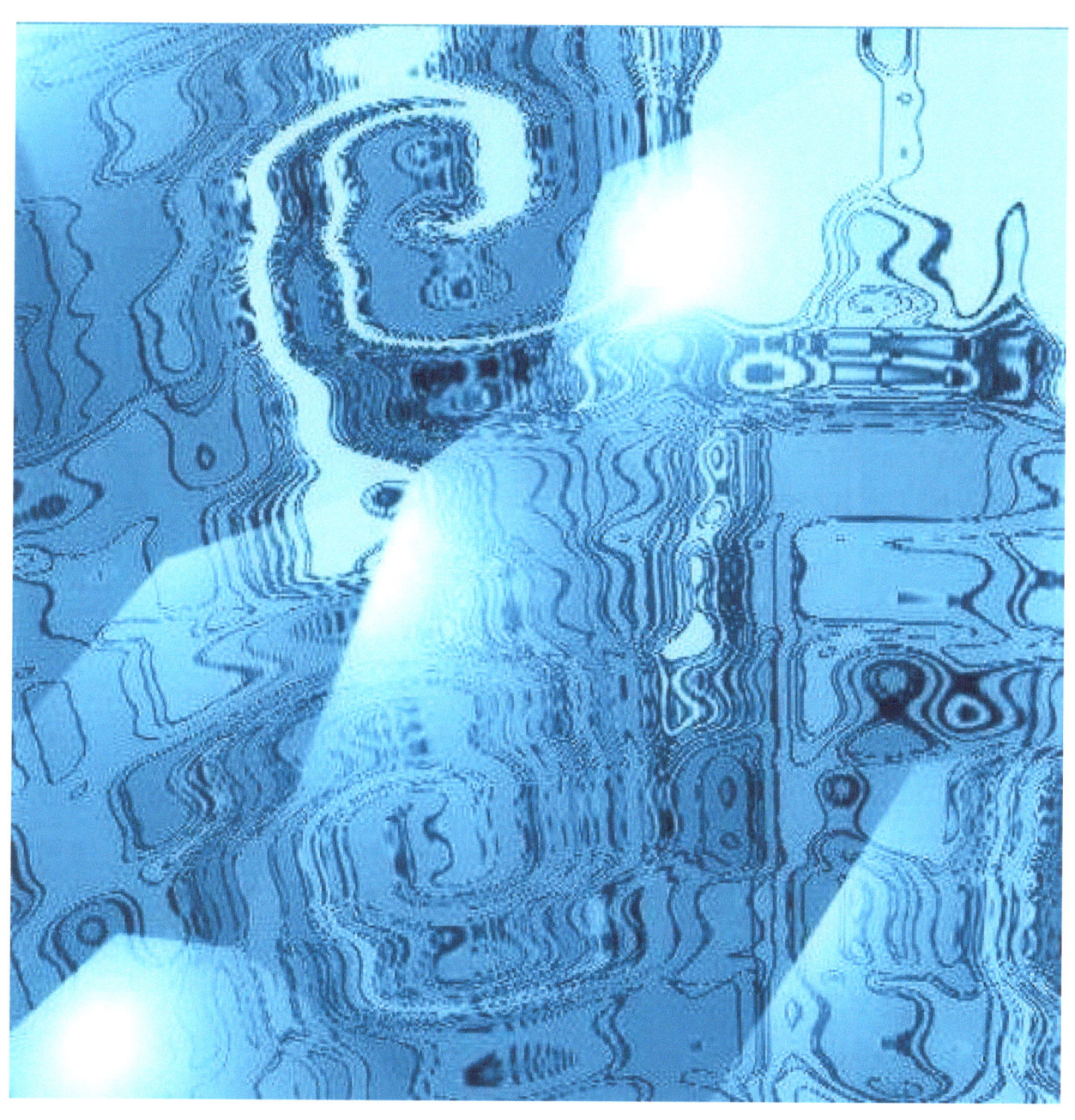

Metropolissimo #9
Screenprint with ink wash and pen and ink

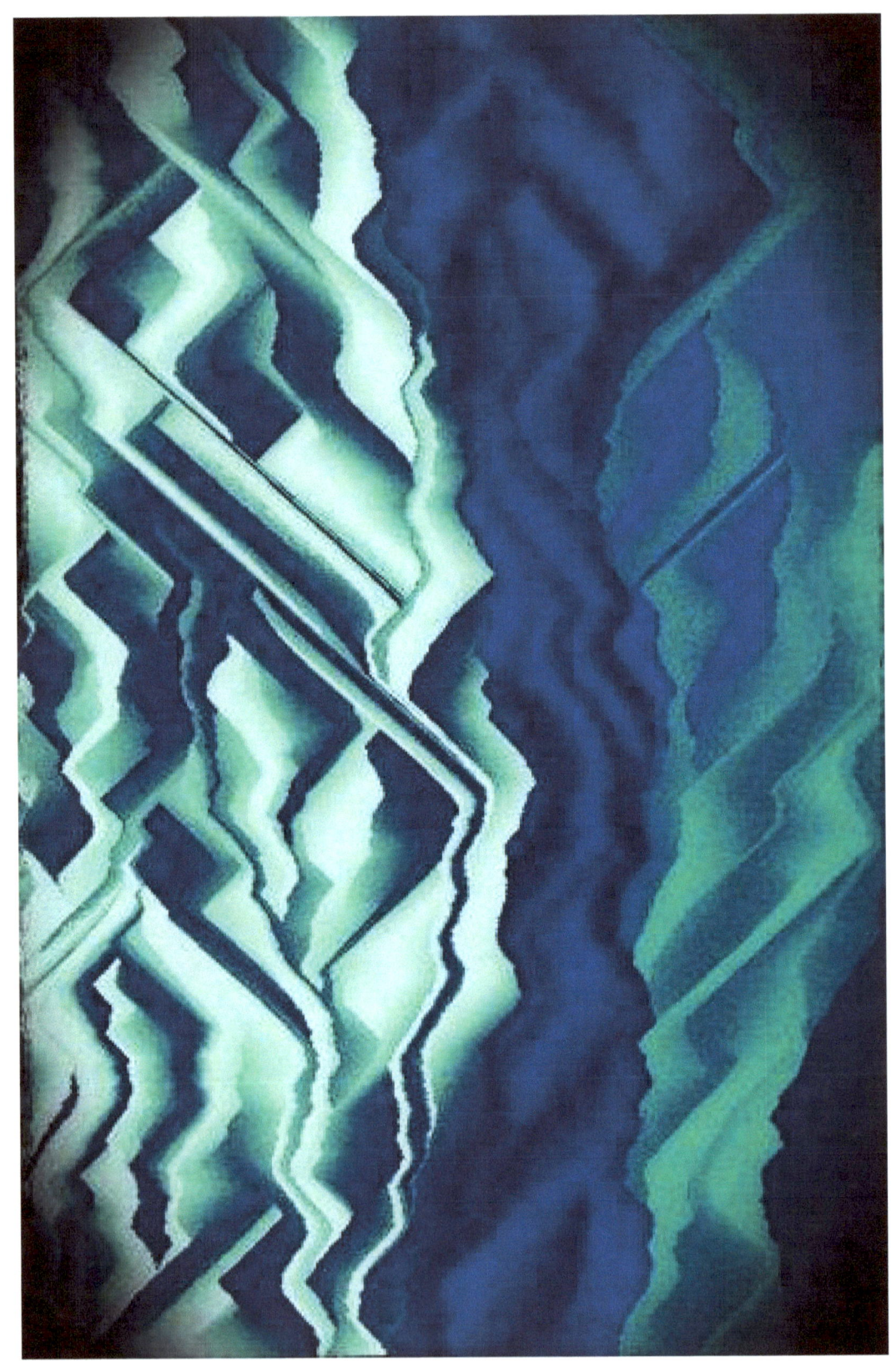

Blue Mountains
Airbrush and ink wash

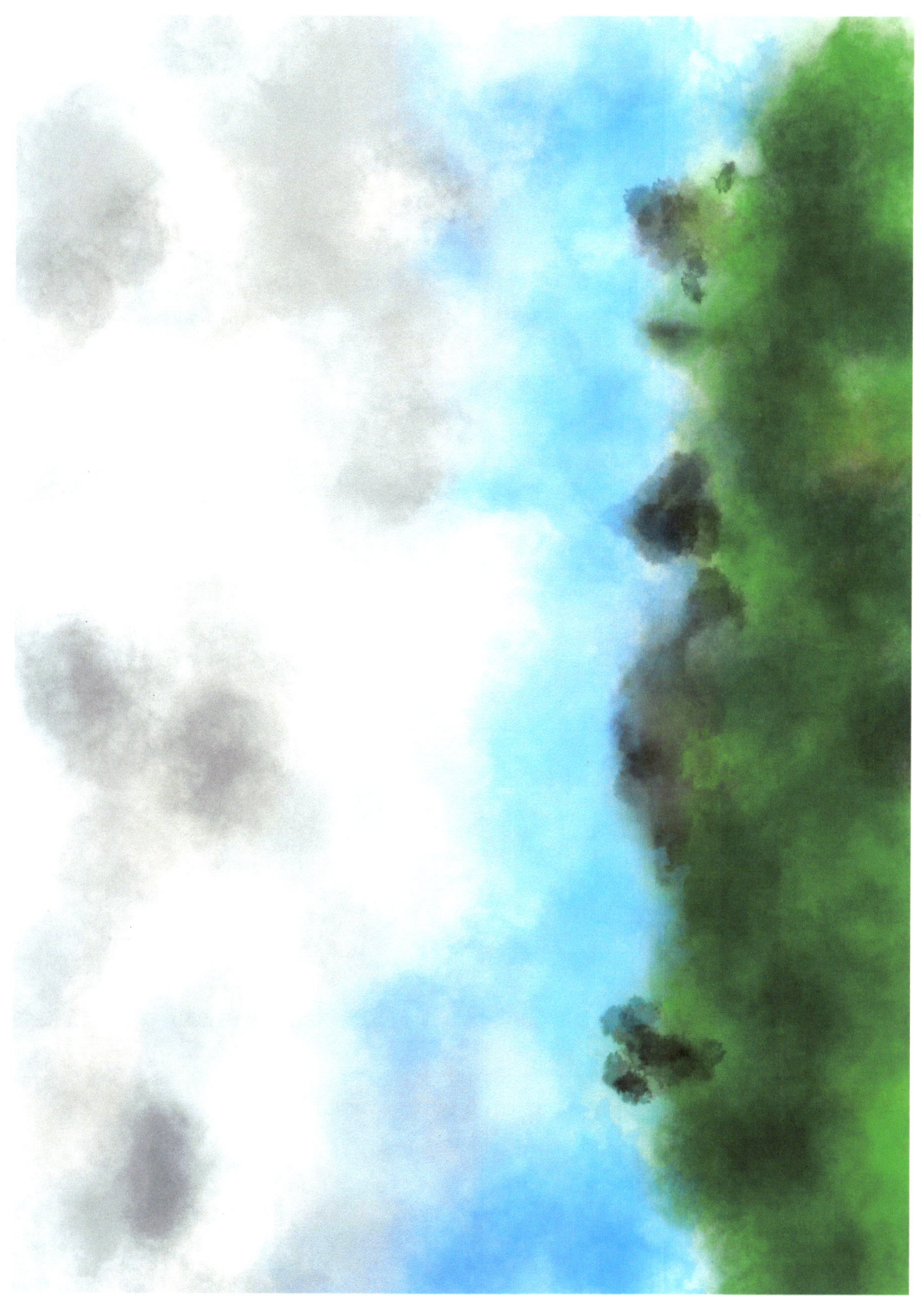

**Summer Field**
**Watercolor sketch**

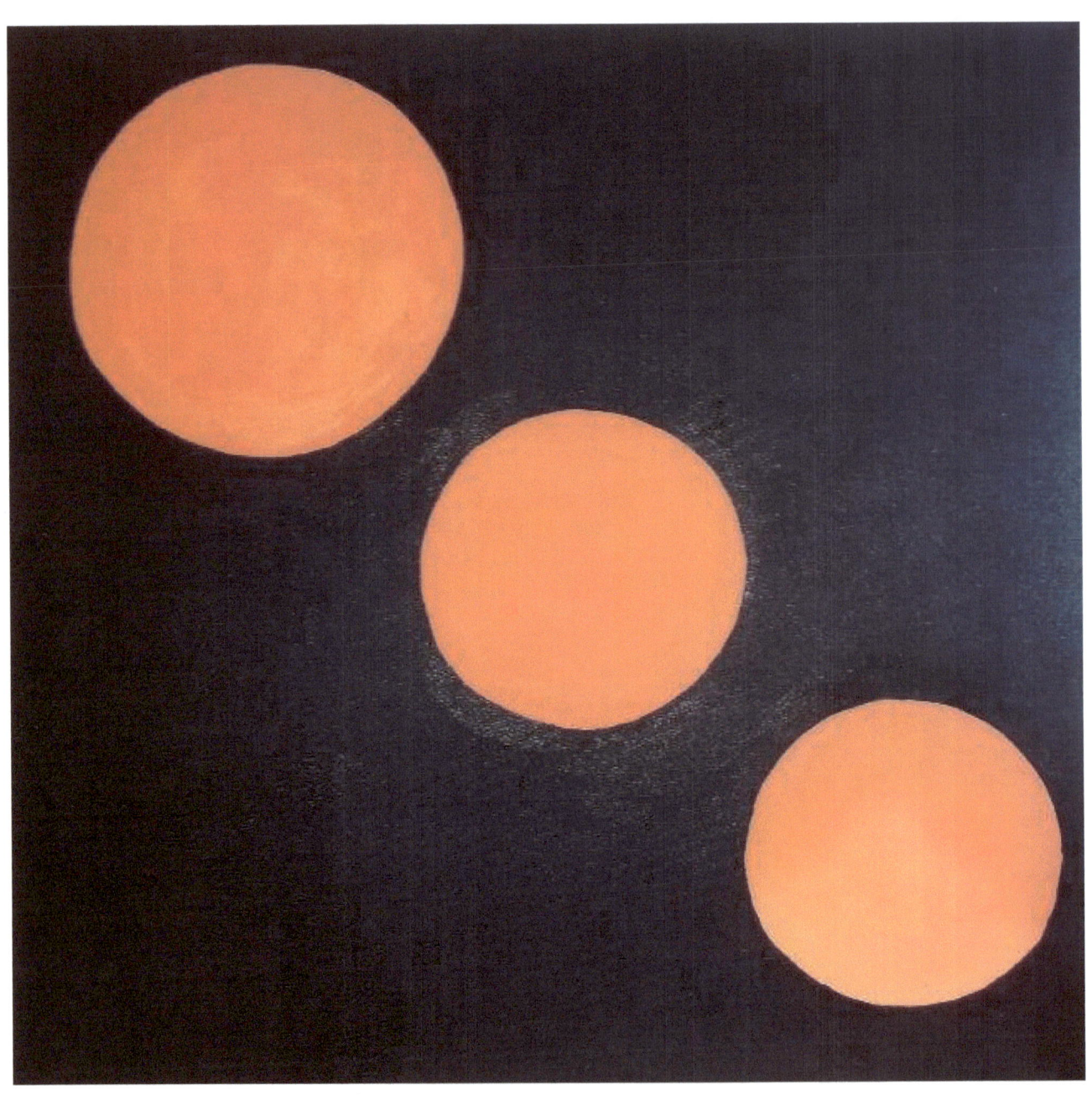

**Order #9**
Acrylics on box canvas

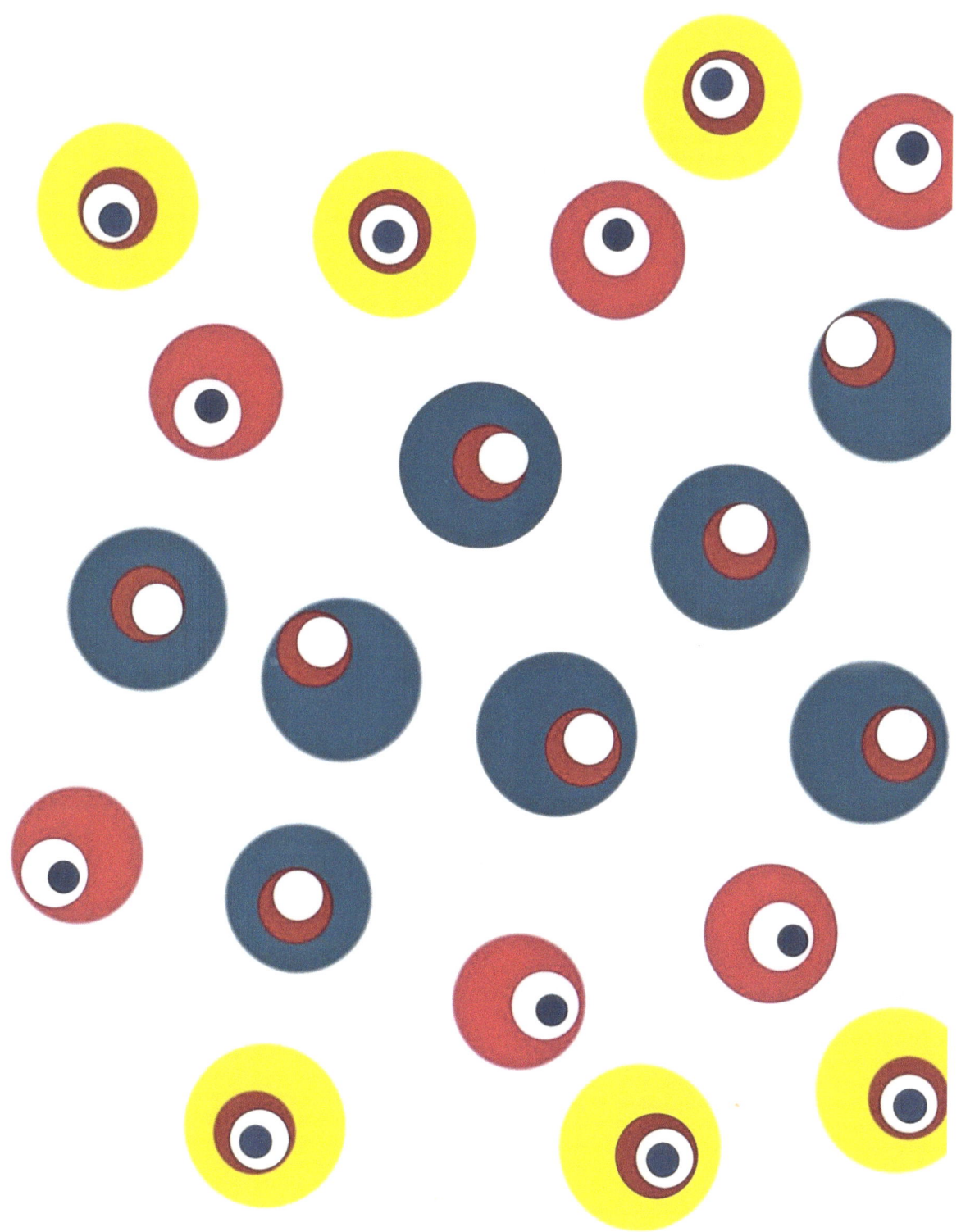
**Bubbles**
**Screenprint**

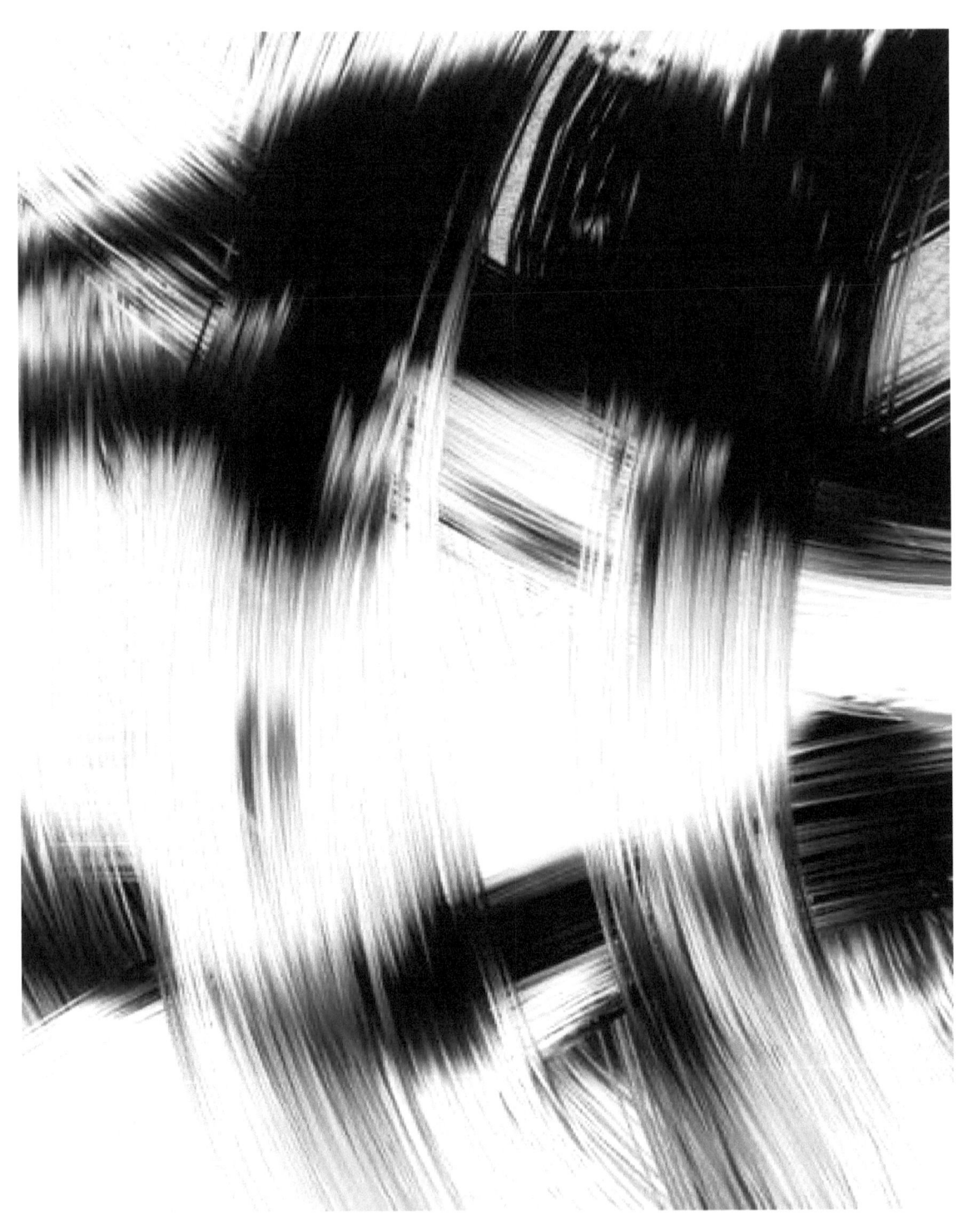

**Self-Portrait #11**

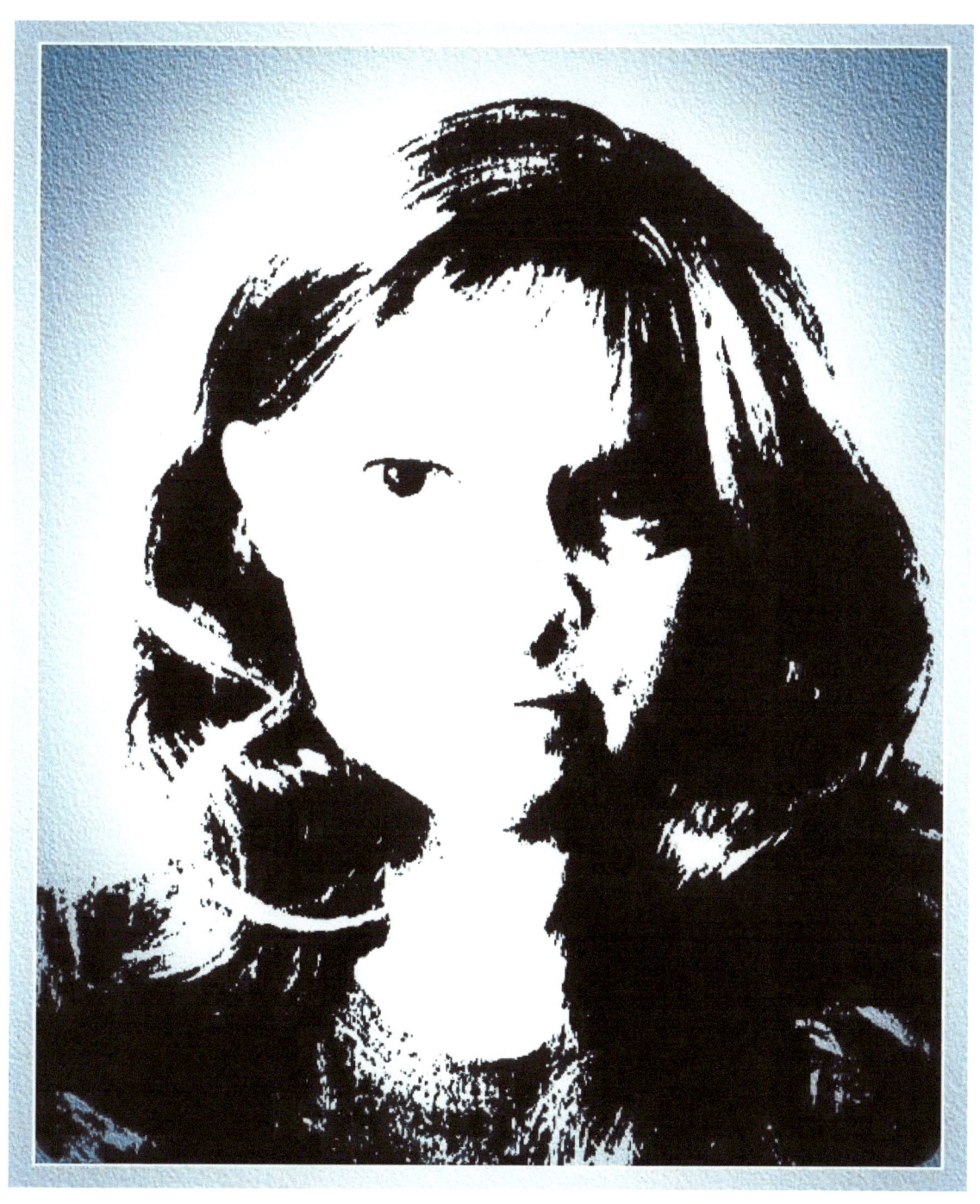

**Self-Portrait #12**

**THE END!**

© MAIA NEWLEY ART 2013

www.ingramcontent.com/pod-product-compliance
Lightning Source LLC
Chambersburg PA
CBHW050806180526
45159CB00004B/1562